EDINBURG.

Ira

Edinburgh Review

Editor: Brian McCabe
Assistant Editor & Production: Jennie Renton
Reviews Editor: Michael Lister
Additional assistance from: Fiona Allen, Julia Boll, Patricia McCaw, Aiko Harman and Ryan Van Winkle

Published by Edinburgh Review
22a Buccleuch Place, Edinburgh EH8 9LN
Telephone +44 (0)131 651 1415
edinburgh.review@ed.ac.uk
www.edinburghreview.org.uk

Advisory Board:
Robert Alan Jamieson, Gavin Miller,
Colin Nicholson, Faith Pullin, Randall Stevenson

Edinburgh Review 127 isbn 978-0-9555745-8-0
issn 02676672
© the contributors, 2009

Printed and bound in the UK
by Bell & Bain Ltd, Glasgow
Individual subscriptions (3 issues annually) £17 / $27 / €27
Institutional subscriptions (3 issues annually) £34 / $54 / €54
You can subscribe online at www.edinburghreview.org.uk
or send a cheque to *Edinburgh Review*
22a Buccleuch Place, Edinburgh, EH8 9LN
Back Issues are available at £5.00 each.

Edinburgh Review
is supported by

⬤ Scottish
Arts Council

Edinburgh Review is a partner magazine with eurozine www.eurozine.com

Contents

Zuhair Al-Jezairy

You Will Be Next
Extract from The Devil You Don't Know

There is a secret history to the country that its people do not know and do not want to know as long as the price of knowing is so high, perhaps as high as their lives. In this secret world Iraqis, including journalists, don't know the most important things, despite the fact that these things play a crucial role in their lives. For example, they do not know that 5 per cent of Iraqi oil revenues belonging to the magnate Calouste Gulbenkian were placed in a secret account when the oil industry was nationalised in 1969 and put at the disposal of the Ba'ath Party; or the size of the defence and internal security budgets, or indeed the amount of oil revenues and how they are spent; they do not know the truth of what happened on 17 July 1979, when a third of the Revolutionary Command Council and a quarter of the Regional Assembly of the Ba'ath Party were executed on a single day, as Saddam rose to power, sweeping away former president Ahmed Hassan al-Bakr; or the death toll from the war with Iran, or even from the second Gulf War; the terms of the Algiers agreement, which renounced Iraqi sovereignty over regional waterways in return for Iran stopping support for the Kurds; the border security agreement which allows Turkish forces to enter Iraqi soil to up to twenty kilometres to pursue rebel Turkish Kurds; the terms of the Safwan Agreement which then defence minister Sultan Hashem signed in 1991 to

end the first Gulf War, giving international organisations evaluation rights over plans for development, imports and industrialisation, something which rendered any talk of Iraqi sovereignty after that point mere idle chatter; Iraqis do not know the extent of extravagant spending by the elites surrounding Saddam and members of his family under sanctions, when the country was starving; the enormous bribes that the regime handed out through the oil coupon mechanism to politicians, parliamentarians and publishers around the world for their support of Iraq's official position; even the weather forecast during the Iran–Iraq war was considered a state secret.

Journalists themselves did not know any of these realities, nor did they investigate stories they would not be able to publish or even talk about. They knew by bitter experience that the censor was never punished for excessive zeal, but rather if he let slip the slightest detail that the authorities on high considered to break the taboos. So the lowly censor would himself increase the realm of the forbidden, and the journalist would do the same thing again. He would rather move the censor inside himself and double it after seeing colleagues taken away from their workplaces, never to be seen again, or coming back broken.

One example I cannot forget is that of my colleague, the photographer Boulos al-Sunati. He was held responsible for the publication of a photo of President al-Bakr in which Bakr's hand, waving to the crowd, was partially cut. The regime did not understand, and did not want to understand, how this could happen through a technical fault. The conspiratorial mind sees foul play in everything. Boulos al-Sunati was strung up by his hands from the ceiling in the torture room for days at a time. When he got out of prison he was broken. His nerves and ligaments were shattered and he could no longer control his own body functions. He died at the age of thirty-five.

Fearful of meeting the same fate as Boulos and others, the journalist would prefer to wait for the official version of any event to come from the official news agency. There was no place for the journalist to find his own information. He had simply to wait for what the regime said, as it was the only source, and the only voice. The people, including journalists, were mere listeners and receivers.

My colleague Jabbar Tarad was operations manager at the newspaper of the ruling party, *al-Thawra*. He told me how he went into the newspaper on the morning of 9 April 2003, the day the Americans entered Baghdad,

but found that according to the official media, nothing had happened. The editor-in-chief pale and confused: 'What distribution are you talking about? Baghdad has fallen and the regime has escaped with their lives.'

At the Aswat al-Iraq news agency, we cultivated the opposite. We familiarised journalists with the practice of looking for information outside the official formulations. I would always ask journalists before they set out from their homes to cover a news event: 'Did you listen to the morning news? Have you read the main items in *al-Sabah* newspaper? Do you have in your head some item you are intending to clarify, or amplify?' I was seeking with these questions to push them beyond being mere receivers of news, to finding information for themselves.

[…]

In Iraq I was to bear a number of names which did not suit me. In the street young men would call me 'pilgrim', or 'uncle', general terms of respect for older men. At work, the young journalists would refer to me as 'doctor' or 'teacher'. And, being over sixty, it is true that I loved being the teacher of these young journalists. I was as anxious to make sure they got more training as I was to ensure that they produced more stories for the agency.

The first thing we tried to teach them was credibility. The hardest thing was neutrality. Neutrality is not just a word that is said. Holding onto it in a country polarised to death is like grasping a hot coal. My correspondents were not from the secular generation spared the pull of sectarian allegiance. They had their own doctrinal, regional and religious affiliations. One of them, for example, from a Shia heartland, would not mention the leading Shia ayatollah Ali Sistani in a news item without adding religious titles, such as 'His Grace', and 'May God Protect his shadow'. I constantly brought him to task, shouting: 'We are not in the seminary. This is an independent news agency. You should use only his formal title "ayatollah".' He insisted he had to use the whole panoply of religious titles to exonerate himself before God and the holy law, saying I could then take out what I liked. But I insisted he had to do it himself. He agreed to separate his religious beliefs from his professional duty in the end, but only after he had officially obtained permission from Sistani's representative.

In areas where religious militias dominate, the correspondent often had

to yield some of his neutrality to keep the militias happy, by restricting himself to quoting only them, for example, or not running stories which would adversely affect their reputations. Knowing this, we had to be very careful with sourcing, and seek balance from elsewhere.

Neutrality made us a target on all sides. Supporters of armed groups launched an attack on us from Egypt, accusing us of collaboration with the occupier because we used the term 'armed groups' rather than 'resistance'. Meanwhile, government supporters would demand we prove our 'Iraqiness', which they defined as using the word 'terrorism' in open copy, not in quotation marks or attributed to a source, as well as referring to dead from the state security forces as 'martyrs'.

Not only were we neutral, we tried to find the common ground that bound Iraqis in the middle of their polarisation. We carried the views not just of the combatants but also ordinary citizens who had no interests in the conflict, the views of victims and refugees from both camps.

The journalist in this atmosphere was both in demand and 'wanted'. Violence in its most barbarous forms is a media act, seeking to pass a message to others that this is what will happen to you if you are not with us. The picture and story amplify the effect of the violence, from the physical victim of the violence to all the others it violates emotionally, with fear. Media and the journalist carry this message. But the journalist also becomes 'wanted' – proscribed – if his work defies one or both of the warring parties. Assassination of journalists has taken the place of censorship. The official censorship of the state withered and vanished after the Ministry of Culture was dissolved. But the censors have increased in number, and are to be found everywhere. Now there is censorship by religious authorities, by society at large, and, most dangerous of all, by armed militias and unknown killers. All of these censorships, and what goes with it in terms of anonymous death threats, form an enormous burden on the journalist. His fears are only increased by the invisible censorship in a society where the true balance of power is not yet clear, nor the boundaries between public and private interests. When the censor is hidden, and taboos are undeclared, writing becomes like walking through a minefield. You never know which story will kill you.

When we opened our office in Baghdad, the first warning came from our guards, who noticed strangers taking pictures of our gates in Waziriyya district. The second came from one of our correspondents, when young men

at the end of the street stopped her car and warned her against frequenting the building.

Somewhere in between assurance and terrorisation, the security advisor gave us advice on how to protect ourselves. Change the time you leave home for work and the route you take to get there. Make sure no one is following you. Be wary of fake checkpoints. Change residence by staying with relatives if you can. But my own experience in Beirut was that it is all Fate in the end. This presentiment, and my own absent-mindedness, taught me that all these security measures, which the killer knew as well as the victim, were really no use. The only difference was the killer could pick his time whereas the victim was hostage to it.

In Beirut I knew I had become the prey of assassins, and I knew the sole reason for it was that I was an oppositionist whose pen had achieved a certain fame inveighing against a dictator whose 'arm is long', as he himself liked to say. Now, 'the reasons are many but death is one': the fact I was hostile to the former regime and a fierce critic of the current one, or that I edited a critical newspaper, or carried a British passport and walked in the street without protection. Last but not least, the fact I am a citizen, and Shia by birth.

Every day I read the news, with that cold hardness created by habit and repetition. The police have found the bodies of people hanged with their own belts... beheaded corpses... bodies in the rubbish bins... bodies, bodies, bodies. And the killer and the victim are always unknown. In fact, I have not got used to the news, despite the repetition. That unknown body is mine.

Sometimes in Baghdad I would go out driving with one of my relatives, a Sunni and a former Ba'athist. I always remind him that really, we shouldn't be in the same car, because we are doubling our chances of assassination. If the death squads want to get him, I will be killed alongside him. If the Ba'athists want to kill me, he will be killed beside me.

But still we went out together.

Assassination is not just a theoretical possibility. I was talking to some relatives in our front garden when four bullets whistled past my face. At first I did not believe it. But then I found the marks and crushed heads of the bullets, one of which was supposed to lodge in my body. I reassured myself, as always: 'I wasn't the target.'

I have started to distinguish between different kinds of death, choosing for myself one which is quick and relatively painless. When I see on TV the

scenes of carnage with knives and swords, I get alarmed. 'I don't want to die like that, at the contemptuous hands of Holy Warriors.'

I have begun to imagine my death. The way they will kill me. Sometimes I play dumb, the role of the unsuspecting victim. Then I quickly flick my eyes left and right when I leave the house, to catch the car that could be waiting for me at the end of the street, or in one of the side streets, or the man who will give the signal to the killers. This fear sits with me until the car enters a crowded street. The crowd gives me the illusion of safety, just being in the thick of ordinary people. My fears fade when I reach the newspaper. Despite its feeble guard system and flimsy walls, I say: 'I'm safe!'

The security advisor told us about all the possible risks. 'You are among the first targets. And you,' he said, pointing at me, 'are the first of the first.'

Saadi Youssef

I Used To
translated by Sinan Antoon

I used to
I often used to hope
as autumn painted forests with gold
brown
or muted crimson
I so hoped to see Iraq's face in the morning
to loosen water's braids over me
to satisfy its mermaids with salty tears
to float over Abu l-Khaseeb's rivulets to ask the trees:
Do you, trees, know where my father's grave is?
…
I often used to hope!
Let it be
Let autumn finish its cycle
Iraq's trees will remain naked
Iraq's trees will remain high
Iraq's trees will be secretly in the company
of my father's face

London, May 21, 2003

Salam Al-Asadi

The Clay's Memory
translated by Salih J. Altoma

The night is a descending myth
a forest of black snow
a sky of mud spitting out its mute ashes over all homes
thus we appear as a blend of tears and dust
no distinction between our children's frightened eyes
and the palm trees' wounds
or between the silence of the schools' empty classrooms
and the sad rumbling of the Euphrates
no difference between the bitter gasp, the sigh of withering souls,
the trees' smoke, the planes' thunder,
or between the fragments of bodies buried in the mud
and the veils of drowned women floating on the river's surface like
numbed shivering black spots
the river that was stunned by the disaster
a storm that sweeps all things into a bottomless abyss
the howl of the planets, rubbles, haggard faces, bewildered eyes,
agitated palm trees, and the bowels of the dead, children's corpses,
and sparrows trembling against closed horizons.

Gunpowder

Dark gunpowder
What a stench that covers the streets with a cruel violent shock
we have nothing but weeping wings mummified by humiliation
And shame
This is the night: doomsday for distraught senses
Do we see, touch, smell, hear, taste, breathe other than sticky mud
which closes on us
Ushering in total ruination?
Once more begins the game of the allies' bombers
a thousand scenes of spectacular and permissible destruction
Piles of ruins
the fires of bombs are still devouring what is left of oil refineries
houses are scattered in a gloomy flash
the town's four bridges totally demolished
and the town split up into two cemeteries of ghosts, of survivors, of
hush cries, and dreary cold

Hassan Abdulrazzak

Long After the Tyrants Perish
A personal look at theatre in Iraq

The first piece of live theatre I ever saw was in Baghdad: a puppet show performed by a Czech company. In the course of writing this essay, I rang up my dad to find out what he remembered about the show. 'Not much. It must have been around '77 or '78. After that we stopped going to the theatre.' It was during the late 1970s that Saddam was busy getting rid of the leftist opposition. My father, a left-leaning academic, was 'asked' to join the Ba'ath party or face the consequences. He neither wanted to face the consequences nor to join the party, so we departed one summer under the pretence of going on a regular holiday. My parents told none of their friends and colleagues. They were even afraid to discuss the matter in front of me lest I spill the beans incidentally at school. I have long thought my parents were deserving of an Oscar for their performance.

Until recently my encounter with Iraqi theatre was limited to watching amateur productions put on by the expatriate community in London. So when I received an email inviting me to attend a screening of a recorded performance of *He Who Remained Awake During His Hallucination*, a play that was staged in Baghdad in 1993, I was very eager to see it. The screening took place in North London at the centre for Dawa, Iraq's most established

Islamic party, and the one to which Prime Minister Nouri Al-Maliki belongs. Perhaps it was because of the location that many of the Iraqi intellectuals I know (who tend to be of the secular, alcohol-consuming variety) did not attend the screening.

He Who Remained Awake is partially based on a long poem by a well-known Iraqi poet who was present at the screening. The play tells the story of a soldier recalling past comrades and old loves in a semi-hallucinatory manner. The soldier's nemesis is a figure called 'the sniper', who looks suspiciously dictator-like. Disappointed as I was by the absence of a coherent plot, the heavy-handed direction and the thick layers of symbolism smeared all over the play with wanton abandon, I was intrigued by its audacity. I had to remind myself that this play was staged in Baghdad less than two years after the 1991 Gulf war, with Saddam still very much in power. There were scenes that not only seemed to be critical of the dictator (albeit in a coded way) but also highlighted the plight of Iraqis over the preceding decade. At one point a dead soldier from the Iraq–Iran war talks of defeat at the front. Officially, Saddam never lost a war. The rhetoric he pumped out daily was that we beat the Iranians despite losing nearly half a million soldiers, crippling the economy and making little in the way of territorial gains. Another scene showed Iraqis lining up to receive food rations from a heartless official who tells a desperate father: 'Every day you come begging for extra rations which you claim are for your young son. When is he going to grow up?' In 1993, Iraqis were still getting used to austere living as a consequence of the cruel sanctions imposed by the United Nations Security Council. The play illustrates how the sanctions (which lasted for over twelve years) hurt the people far more than the government.

The coded anti-government gibes are smothered however by other scenes that echo rhetoric of the time. UN officials are shown as being uniformly unfeeling and hell-bent on Iraq's destruction, whilst neighbouring Arab countries are described as 'traitors'. Clearly the playmakers had to appease the powers that be.

The day after the screening, I met my friend Z for a shisha and a chat. Z trained as an actor and director in Baghdad. He knows almost everyone in the theatre scene there. He is also very honest about the past.

'Look, we all pretend now that we were heroes under Saddam, putting on daring work, but the truth is that it was our dream to get banned! The

government simply didn't care about us. You couldn't put on anything that clearly and directly touched Saddam and his family but we still managed to get away with far more than you can imagine.'

According to the poet upon whose epic the hallucination play is based, the government tried to shut down the show after a couple of performances. A buzz began to go around about the audacity of the play, to the point where officials felt that to ban it entirely might lead to unnecessary agitation. A censored version was staged again. Shortly after that, the poet, fearing for his life, left Iraq.

Z, though an admirer of the poet, is sceptical about certain elements of his story: 'He had a good position in Iraq and friends with powerful connections who protected him. He was invited to a festival in Jordan and used the opportunity to flee the country. Perhaps like a lot of people he was simply fed up of living in Iraq and wanted a way out.'

An instinctive distrust of each other's motives is one of the many terrible legacies Saddam left us with. Another legacy is illustrated by the following theatre-related story.

A few years ago I saw an amateur production of a play called *Curfew* at the Polish Centre in Hammersmith. The play was accomplished and proved a tremendous hit with the Iraqi community. It told the story of two working-class Baghdadis, a car washer and a shoe polisher, living together in an abandoned house after the fall of Saddam and sharing with each other stories and their meagre stock of cigarettes and arak (a popular Iraqi drink, rather like ouzo). What excited me about the play was that it was narrated from a working-class perspective by characters who had a natural poetic cadence to their speech. At one point the two heroes peer over the wall of Baghdad's College of Fine Arts and see a woman trying desperately to wash away the blood on her hands. They describe what they are seeing with a childlike innocence and it slowly dawns on us, the audience, that what they are witnessing is not some horrific aftermath of a suicide bomber but an actress rehearsing the part of Lady Macbeth. I was keen to translate the play into English so that it could have an audience beyond the ex-pat community. Then one day someone who knew about my interest in the play emailed me a newspaper article. The actors who had developed *Curfew* in Iraq were complaining that the fruits of their labour had been stolen from them. They alleged that the play was the product of collaboration between themselves

and the writer/director who came up with the story. However another actor, working as part of the backstage crew brought the play to London without consulting them. He used it as means of gaining entry into the UK, where he hoped to claim asylum. I decided to drop the idea of translating the play as I could not be sure who to approach in order to obtain the legitimate rights to it. The chaos, corruption and desperation illustrated by this story reflect the wider picture of what is happening in Iraq. The desire to get out of the country, to flee to an imagined better life in Europe, can lead to acts of betrayal and outright criminality. This is also one of the legacies Saddam saddled us with.

Iraqi theatre wasn't always tainted in this way. One of its biggest stars is the director and playwright Yusuf Al-Ani who wrote social and political dramas that engaged Iraqi audiences and raised their social consciousness. He was amongst the first to champion plays where the parts were spoken in an Iraqi dialect rather than in classical Arabic, so that they might touch the common man. However with the rise of the Ba'ath party and the elimination of the secular left in the mid and late '70s, many of Iraq's brightest theatre talents had to flee the country.

For some, like the actress Nahida Al-Ramah, their career more or less came to a halt. Nahida, once the darling of the Iraqi stage, now lives modestly in London. In *Wasteland: Between London and Baghdad,* a moving documentary about her life made by filmmaker Koutaiba Al-Janabi, she describes her first experience of going to the theatre in London:

> I went in, sat down and a strange feeling overcame me, replacing the initial happiness of being back inside a theatre. I looked around and realised I was now a spectator, not a performer. When the lights went down and the actors took to the stage, I nearly lost my mind. I had the irrepressible desire to join them on stage, to scream that I wanted to act again. I tried to hold myself together but could not stop weeping. People began to stare at me. I struggled to muffle the sound of my cries. Afterwards, I went backstage to speak with the actors but could not express myself properly in English.

For other theatre practitioners, leaving Iraq provided an opportunity to expand their artistic horizons. Exile forced Jawad Al-Asadi to work in Eastern

Europe, Syria, Lebanon, the UAE and elsewhere. Over the years he became one of the most influential theatre directors in the Arab world and winner of numerous honours, including the 2004 Prince Claus Award. When I met him few years ago in Beirut, he was in the midst of establishing a new theatre in the Lebanese capital. Despite living outside Iraq, the chaos and madness of the post-Saddam era did not fail to touch him. In 2007, armed men dressed in the garb of Shia militia stopped his brother and nephew as they were driving. Like most savvy Iraqis, Jawad's brother carried two IDs: Sunni and Shia. He presented his Shia ID to the militia men. It was a trap. They were Sunni. Both father and son were tortured for days, then executed.

With such horror as background, theatre may seem like an unaffordable luxury. I do not subscribe to this idea. Events have moved at such a neck-breaking speed since 2003 that the opportunity to reflect on the past has been limited. Why did Saddam assume and hold onto power so effectively? This and countless other questions are rich material for a dramatist.

Iraqi theatre could flourish once again. Theatre practitioners need to make contact with the outside world. Actors, directors and playwrights should be granted scholarships (and visas!) to train outside the country and be exposed to different styles of theatre.

Muhammed Mahdie Al-Jawahri (1899–1997), one of Iraq's best loved poets, once wrote addressing the nation: 'You shall remain long after the tyrants perish.' Our tyrant is gone. But could tyranny take hold once again, or will our fledgling democracy succeed in sprouting unshakable roots? Theatre has a role to play in determining the outcome.

Hannah Adcock

Wandering Western Women

For men may come and men may go but I go on for ever
'The Song of the Tigris River' (quoted by Isabella Bird)

'Of all that once was in this ancient land, the swirling River Tigris alone remains, singing in every eddy and ripple'; or so imagined Isabella Bird in her 1891 travel narrative *Journeys in Persia and Kurdistan.* The Tigris, 1,180 miles long, originates in the Taurus Mountains at Lake Hazar, Kurdistan, and flows through Turkey and past Baghdad to unite with the Euphrates River at Al Qurnah in south-eastern Iraq.

Bird quotes this snatch of song about the river early on in her book as she makes her way by steamer to Baghdad. It is both a simple allusion to the incredible history of the area, which stretches back to c. 10,000 BC, as well as a very personal reflection on mortality. By the time that Bird stood on the banks of the Tigris she was already an acclaimed traveller and travel writer. She had written books on America, Korea, the Sandwich Islands, the Rocky Mountains, Japan and Malaya, and had struck up a firm friendship with her publisher, John Murray. She had been brought up in Edinburgh but was unable to contemplate the 'undendurable climate' of the Isle of Mull, where her sister had settled. In 1886 she planned to ride across little known parts of Turkey and Persia, to visit Christian outposts and the ancient communities of the Armenians and Nestorians. She was struggling to come to terms with

the death of her beloved sister and husband, whilst she herself was fifty-nine and not in the best of health. It must have been easy to watch this ancient river that had sustained civilisations through the ages, from ancient Nineveh to the tarnished splendour of Baghdad, and reflect on the transience of life.

Just over ten years later, another, much younger, traveller, Louisa Jebb, stood on the banks of the Tigris. She was also prompted to reflect on the nature of time by the eastern lifestyle and the river's meanderings. Louisa was one of a select number of women who took the agricultural diploma at Newnham College, Cambridge under the principalship of Mrs Sedgewick. There she had formed a friendship with the adventurous Victoria Buxton (later Mrs Victoria de Bunsen, although referred to as 'X' in *By Desert Ways to Baghdad*, published in 1907). The two had decided to embark on a journey through Asia Minor, from Constantinople via Tarsus to the headwaters of the Tigris, sailing down to Baghdad, and returning to Damascus through the Syrian desert. Jebb writes in with the suave assurance of youth: 'Ignore time and he is at once your servant: treat him with respect and he at once becomes your master.' However, this pithy piece of wisdom, dispensed in the prologue, is something that she doesn't always quite believe. In an amusing exchange with X she writes:

'X' I said, 'where do you think we are floating to?'

'Baghdad,' said X.

'I wasn't thinking geographically,' I answered, 'I was thinking whether it was Eternity of Oblivion. Being hurried along by the current gives me an uncomfortable feeling of not being allowed any choice as regards times, which I resent. Do you mind it at all?'

'No,' said X, 'I feel that I have lost all conception of time, and that we are floating on, as it were, to Eternity.'

'Do you?' I said dubiously; 'I feel it's Oblivion we are getting to.'

'But we are only three days off Baghdad,' insisted X.

'Well,' I answered, 'I devoutly pray that we may get there first.'

It is hardly surprising that the two travel books, *By Desert Ways to Baghdad* and *Journeys in Persia and Kurdistan* are very different. After the death of her husband in 1886 Bird had resolved to travel again – but not for her own health and amusement. She would visit medical missions in remote lands.

The tone of her book is intelligent, she is not afraid of using statistics, and she has an appealing, dry sense of humour. As a contemporary put it, she was a 'very solid and substantial little person, short but broad, very decided and measured in her way of speaking'. Or in her way of writing, one might add.

Jebb, in contrast, speaks with a fresh, occasionally idiosyncratic voice. Her personality dips and dives through the narrative, taking it to peaks of philosophy, or, just as easily, lowering it into 'untrammelled manners' and 'emblems of all the great abiding truths', with barely a batted eyelid. It is a slightly surprising book from a woman who took an agricultural diploma and went on to be instrumental in the establishment of the Women's National Land Service Corps, becoming the outstanding pioneer of the smallholding movement, or at least its revival; but of course, practicality and creativity need not be mutually exclusive.

Jebb's prologue tackles head-on any apparent inconsistencies. She writes that X 'had unearthed me from a remote agricultural district in the West of England with the idea that contact with the agricultural labourer would have fitted me for dealing with the male attendants who were incident to our proposed form of travel'. From the beginning, it all feels like a bit of a joke. The women decide on their route with the aid of a ruler, a pencil and a mutual desire not to go anywhere near the sea. 'That will do for a start,' says X, 'we can fill in the details when we get there.' It is this sense of camaraderie and mutual endurance that gives *By Desert Ways to Baghdad* an appealing edge. Jebb writes about her indomitable companion: 'The worst of X was that you never knew whether she was laughing at you. It is most uncomfortable position, which men as a rule resent. But I was another woman, and took it philosophically, especially as X accused me of the same failing.'

Bird, in contrast, has no female sidekick and chooses to write in an epistemological form. She did, however, have as her escort a 38-year-old widower, Major Sawyer of the Indian Army, who is referred to as M—. He was a military surveyor on a secret reconnaissance mission to ascertain both the extent of Russian infiltration in the Middle East hinterlands and more precise geographical data about them. For obvious reasons, not least that the Indian War Office vetted *Journeys in Persia and Kurdistan* before it was published, Bird mentions him only rarely. It seems likely though that she would have preferred to travel alone, as she had in the past. She viewed any companion as 'an infringement on my liberty', according to Pat Barr in

her 1988 Introduction to the book, but the area was exceptionally difficult for a European woman to visit alone. Bird and the Major became 'good comrades', although when they finally parted after their second expedition at Burujird, she privately expressed her relief that he would no longer rouse her at dawn with his call, 'To boot and saddle.'

The two accounts also differ in their descriptions of place. Bird records her impressions of Baghdad, 'which are decidedly *couleur de rose*', with good humour and a fine eye for detail. Her long sweeping sentences build up an intensely vibrant scene, enlivened by her dry interjections.

> The splendour of the East, if it exists at all, is now to be seen in the bazaars. The jewelled daggers, the cloth of silver and gold, the diaphanous silk tissues, the brocaded silks, the rich embroideries, the damascened sword blade, the finer carpets, the inlaid armour, the cunning work in brass and inlaid bronze, and all the articles of *vertu* and *bric-a-brac* of real and spurious value, are carefully concealed by the owners, and are carried for display, with much secrecy and mystery, to the houses of their ordinary customers, and to such European strangers as are reported to be willing to be victimised.
>
> …
>
> The natural look of a Moslem is one of *hauteur,* but no words can describe the scorn and lofty Pharisaism which sit on the faces of the Seyyids, the descendants of Mohammed, whose hands and even garments are kissed reverentially as they pass through the crowd; or the wrathful melancholy mixed with pride which gives a fierceness to the dignified bearing of the magnificent beings who glide through the streets, their white turbans or shawl head-gear, their gracefully flowing robes, their richly embroidered under-vests, their Kashmir girdles, their inlaid pistols, their silver-hilted dirks, and the predominance of red throughout their clothing aiding the general effect. Yet most of these grand creatures, with their lofty looks and regal stride, would be accessible to a bribe, and would not despise even a perquisite. These are the *mullahs,* the scribes, the traders, and the merchants of the city.

Jebb tends to prefer a dramatic, poetic style, particularly when it comes to describing such a historically resonant place as Babylon:

We wandered amongst the huge ruins, balancing ourselves on the edge of low remaining walls and clambering from one courtyard to another. A jackal darted from under our feet with a shrill bark; he was answered from behind distant walls by innumerable hidden companions. An owl flew out of a dark corner and perched, blinking, a little way off; a great black crow hovered uneasily overhead. The broad walls of Babylon were indeed utterly broken, and her houses were indeed full of doleful beasts crying in her desolate houses; it was indeed 'a dwelling place for dragons, an astonishment, and an hissing without an inhabitant'.

Shamash, the Sun-God, was nearing the western gate of heaven. The gate-bolts of the bright heavens were giving him greeting.

The Euphrates and its wooded banks lay between us and the horizon; above the river-line we saw a row of jet black palms in an orange setting, and below it a row of jet black palms standing on their heads in the rippled golden water.

Like most Western travellers, Bird and Jebb were dependent on a number of different local men. Bird is disparaging about her servant, Hadji, who uses exasperatingly pious phrases to cover any shortcomings. Jebb is equally annoyed by a number of her employees, going so far as to label one particularly malevolent *kalekji* 'The Evil One'. Faced with his intransigence, she resorts to pointing a pistol at him until he rows. 'Greatly to my astonishment,' she writes, 'The Evil One appeared to believe in the possibility of bloodshed and set to work at the oars. All the rest of the day I sat with my revolver at his head. It was a most fatiguing, if effectual, process.' Conversely though, she has nothing but praise for a noble Alabanian Turk called Hassan, who 'looked every inch the gentleman he was'.

The women converged on Baghdad from different directions: Bird took a steamer from Basra on the Persian Gulf, and headed north-west:

In spite of the shallows at this season, the Tigris is a noble river, and the voyage is truly fascinating. Not that there are many remarkable objects, but the desert atmosphere and the desert freedom are in themselves delightful, the dust and *débris* are the dust and *débris* of mighty empires, and there are countless associations with the earliest past of which we have any records.

She passes time staring out at the banks, mentioning with a certain laisser-faire, 'The first object of passing interest was Kornah, reputed among the Arabs to be the site of the Garden of Eden.' She then notes, 'the night was too keenly frosty for any dreams of Paradise'.

Bird's only mild adventure on the Tigris came when the steamer ran aground 'with a thump', injuring one paddle-wheel and obliging passengers to stay for part of the night near the ruins of the ancient palace of Ctesiphon while it was repaired. It was hardly a tragedy, for 'its gaunt and shattered remains have even still a mournful grandeur'. All her grand adventures were to be played out overland after Baghdad.

Jebb and X, in contrast, travelled down the Tigris to Baghdad, after an overland journey through Anatolia. The Tigris section of *Desert Ways* is called, rather accurately, 'Down the Tigris on Goatskins'. So, you have the younger, inexperienced women heading down the Tigris on goatskins whilst the older, seasoned traveller heads up the Tigris in the comfort of a steamer. It is an amusing comparison, which undoubtedly says more about the relative development of the north and south portions of the Tigris than it does about the respective women's priorities.

One theme that they share, however, is the obvious one. They are women travellers at a time where British women did not even have the vote. A clergyman's daughter, Bird was encouraged with her practical philanthropy, but hardly expected to go exploring little-known corners of the world by herself. More importantly, they were visiting a land of harems and chadars: 'It had not occurred to me that I was violating rigid custom in appearing in a hat and gauze veil rather than a chadar and face cloth, but the mistake was made unpleasantly apparent,' writes Bird, about her experience in Aimarah. Women, on the whole, stayed within buildings. Though 'men may come and men may go', women on the whole could not – unless they were Western women ready to defy convention (Western and Eastern).

Jebb and X, however, had one major advantage over Bird: rumour spread, like wildfire, that they were western 'Princesses'. The inferiority of their sex could not quite be forgotten, but it was at least mitigated by their apparently illustrious pedigrees. Welcoming parties were sometimes sent out to meet them, a far cry from the treatment often meted out to foreign women (or any woman). In nearby Tehran, Mary Sheil, the English ambassador's wife, was relegated to the goods train when her husband made his triumphal state

entry. But how had such a rumour come about? Jebb explains:

> We had left our cards on the officials at the Konak. Now X's Christian name was Victoria, and her address printed on the card was Prince's Gate. To the Turkish mind this was conclusive evidence that she was a relation of the great Queen, and instructions for our suitable reception were accordingly telegraphed on. At Adana we found ourselves indisputably 'daughters of the King of Switzerland'.

It was of no use denying it: 'naturally we wanted to preserve an *incognito.*' They found themselves explaining why they had no husbands, a subject on which they mixed a dry sense of humour with a healthy desire to preserve their own social standing and security: 'In England the ladies do not care about husbands. In that country they rule the men. If anything were to happen to these ladies, the Queen of England would send her soldiers out here to revenge them.'

Bird is not quite so keen to make a joke about the relationship of the sexes, imbued as she was from youth with conventional social and moral Victorian standards. She was elected the first woman fellow of the Royal Geographical Society but had no real taste to become an apologist for the women's movement. Barr considers that she 'viewed her own original life as something of an unnatural aberration for a mere woman', and that her later travels could be at least partly explained by the fact that she didn't wish to become enmeshed in 'causes'. It is certainly interesting that whilst ensconced in British domesticity she suffered a complex collection of maladies, but was in her element when enduring some of the toughest conditions known to man.

Journeys in Persia and Kurdistan is the first book in which Bird makes frequent reference to her Christian beliefs. She offers sensible observations about the difficulty of mission life in the Middle East, especially for single women, which was not particularly heeded by church societies back home. Hers is a political book, in the sense that it is a repository for valuable information, historical, social and political. Jebb, in contrast, doesn't really seek to advise or inform. She is less analytical than Bird, taking away from the East a more mystical, personal awareness of time and the value of silence.

Haifa Zangana

Baghdad

Extract from Dreaming of Baghdad
translated from the Arabic by the author, with Paul Hammond

I was twenty years old. I stood in the middle of a room in front of four men. My boxes of books and pamphlets, a huge desk, recording machines, and a sofa were against one of the walls; leftovers of a meal remained on a tray. The man sitting behind the desk did not say much. His name was Nazim Kazar, and he was the head of the Iraqi secret intelligence. He was of medium height, with dark skin, and wore sunglasses with gold rims. He had on a dark suit and held a rosary. He divided his attention equally between it and me, as if debating something.

He was lord and master of the palace Qasr al-Nihaya, the detention centre for political prisoners in Iraq. He knew everything that took place within its four walls. He received visitors and delegated them to various rooms. While the government was maintaining its façade of civility and the Communist Party's main opposition was busy polishing a few bricks in the hope of securing a couple of seats in the government, this man had absolute freedom in arresting, torturing, and executing detainees in the labyrinth of that castle.

Four years later, at noon on a hot, sunny day, the master of the palace, Nazim Kazar, suffered the same fate: he was arrested, tortured, and executed by his own government.

What was to become of me? One of the men prowled around me, and then touched me. As he did so, I could hear the laughter of the other men in the room. I was so scared, I had no time to be disgusted by the slimy hands touching my body. I looked at the curtains, the walls, the boxes of books, and, as I smiled stupidly, the man hit me across the face, his coarse words swirling around my body. When he hit me on the head, lights danced in front of my eyes. I was pushed against a wall. The master, who so far had remained calm and silent, now moved for the first time and told his men to leave me alone. Approaching me, he pointed to my clothes, and I quietly put them on. He told me to sit beside him, and asked me softly, 'Are you hungry?'

'I want to go to the toilet.'

One of the men accompanied me to the toilet on the first floor, which was not an easy task, as he had to stop me time and again and order me to face the wall as other prisoners filed by. After they had gone, there were drops of blood on the ground. I followed the man to the first floor and he showed me to the toilet. No, it was a just a room with a tub. I turned around, confused. He said, 'What's the difference? Do what you want to do here,' and he stood behind me. I urinated and returned with him to the hall.

There the master asked me to sit next to him and eat dinner. 'And now… I want you to tell me everything you know.' He patted me on the shoulder tenderly, as if he were a friend I had not seen in a long while, and all he wanted was to hear my latest news.

'About what?'

'It doesn't matter. Tell me about anything.'

Remain silent for two days. Those had been my instructions. After that, people would get to know about my arrest, meetings would be cancelled, hiding places would be changed. Two days of silence: this was the lullaby I comforted myself with, and a smile coursed through my shivering body. The master of the palace stood up and said, 'It seems you are all alike. I thought you were an intellectual with nothing in common with those ignorant people.'

He left and I did not see him again. For a while, I was alone. The palace was very quiet. The thumping of my heart eased off; I began to think of the others, something I had done my best to avoid until then. Suddenly the door opened, and a short little man entered, followed by four henchmen. With

his bulbous eyes he supervised everything that took place in that room and thoroughly enjoyed the moans and screams of the tortured. Four years later, at noon on a very hot day, that little man called Hassan Al-Mutairy went through the same tribulations; like the master of the palace, he was arrested, tortured, and executed by his own government.

He looked at one of his men, who then left the room and returned with a fellow officer, dragging in a prisoner. The prisoner's head was swollen and covered in dried blood. The two men dropped him on the floor. I was surprised when the victim whispered my name, and then I recognised my friend, a friend of my family's. Here was a man my family loved, a man whose visits we eagerly awaited. We adored spending long hours listening to him at night, to the tales of his imprisonment and how all the comrades cared about him because he was the youngest, how his jokes helped people pass the time and forget their fears of interrogation and torture. He did not look towards me now; he was no more than a mound of flesh encrusted with dried blood. He confirmed my identity and then he was dragged out of the room. That was the last time I saw him. Two months later he was executed with two other comrades; one was twenty-three years old, the other sixteen.

Many others were brought into the room. All of them had been tortured and disfigured to the extent that I only recognised them by their voices. The room became smaller and smaller…

Was I going to tell him anything? Two days of silence were all I had to bear. I looked at him idiotically. Things happened so quickly I didn't have time to think. An exhausted looking man came in and began beating me and kicking me in the groin. My underwear was wet with blood and urine. Then someone kicked me in the head.

When I awoke I was in a small room, empty except for an old sofa. One of the windows faced a high fence; I must have been in the south wing of the palace. The floor tiles were stained with dried blood, which I tried to scrape off with the toe of my shoe and push to the other side of the room. Despite terrible pain, I kept on trying. There were people's names scribbled all over the walls. Realising it was daytime, I knocked at the door. When at last it was opened, I asked permission to go to the toilet. The man told me to urinate in the room and locked the door quietly. I thought they must be busy with new detainees. New prisoners.

I spent two weeks in that room. On the second night, or maybe the third,

and after the little man had stopped sending for me many times a day, I realised why the beatings had stopped: I must be their personal favorite, their current VIP. Then, on the third night, I heard screams like none I had ever heard before. Was it a human being screaming or an animal howling? It was a mixture of a human voice denying knowledge and a continual howling, interrupted by sudden screams, followed by a voice begging and pleading for mercy, followed by more screams.

For two weeks, I could not sleep. I listened by day for the torturer's steps to approach and take me to be interrogated again, and by night I tried to recognise the voices of the tortured, to discover who else had been arrested.

One day I was visited by the prison doctor, who gave me some antibiotics, and on another day by one of the torturers, who felt sorry for me when he saw both my legs and skirt were covered in menstrual blood. He gave me an old shirt which I cut into pieces and put between my legs. He grew more sympathetic and allowed me to go to the toilet, and finally handed me a broom and a bucket to clean the room of excrement and urine.

The men got used to my presence there and stopped ordering me to face the wall whenever they pushed another prisoner by. Once, while standing in a queue to go to the toilet, I stood behind a prisoner who was carrying a bucket of excrement and urine. The guard was annoyed because one of the prisoners was taking a long time in the toilet, so he ordered the prisoner with the bucket to throw its contents over the tardy comrade when he emerged. The torturers' laughter was louder than usual, their amusement endless. Ordering the prisoners to clean the floor, a guard led me back to my room, and I was deprived of going to the toilet at all that day.

While I was in the palace, I had the privilege of a visit. One of my influential relatives visited me for a few minutes. That meant my family knew I was alive, and they were trying to get me released. Indeed, if what my relative said was true, I was about to be released very soon. After two days, two men entered the room and ordered me to follow them. At the palace gate they stopped and blindfolded me. There my temporary elation ended. I sat between them in the back of a car, and we began our journey of many miles. Questions swirled in my head. From some of their comments, I inferred that they were taking me somewhere to execute me. Sitting stiffly, I thought that maybe I was already dead. Suddenly, I could not hear their questions and comments. I had no idea if the journey had lasted a few minutes or many

hours. The car stopped. I burst into tears for the first time since my arrest. No, the journey was not to execute me, but to transfer me, thanks to my father's efforts, to Abu Ghraib, an ordinary prison.

I was released after six months, during which time I was moved again, to a prostitutes' prison. I had become ill, my face was covered in sores. I cried for any tender word or gesture. My hair began falling out. For a whole year afterwards, I was reduced to an entity closed in upon itself, absorbed in remembering that howling, remembering the dead.

Andrew Philip

Five poems efter Sinan Antoon

A Prism; Weit wi Wars

this is a chaipter o
devastation
this is wir oasis
an angle whaur wars intersect
tyrants accumulate aroun wir een
in the shaikle's verandah
there eneuch space fir applause
let us applaud

anither forenicht sclims
the city's caunles
technological hoofs crushes the nicht
fowk is gettin slauchtert atour short waves
but the radio boaks raw statements
and caws us tae
applaud

wi a skeleton o a burnin umbrellae
we receive this rain
a god sleeps on wir flag

but the horizon is prophetless
mibbes they will come gin we
applaud
let us applaud

we will baptise wir bairnies wi reek
plou throu ther tungs
wi flagrant sangs o war
or UN resolutions
learn them the bray o slogans
and leave them aside burnin paps
in an imminent wrack
and applaud

afore we weave a hairst for tyrants
we maun cross this galaxy o jaggie wires
and keep on repeatin
A GUID NEW WAR!

Absence

when ye leave
the place wizens
Ah gaither the cloods
skailt bi yer lips
hing them on the waws
o ma mindin
and wait
for anither day

When Ah wis torn bi war

Ah taen a brush
Dookit in daith
And drew a windae
On war's wa
Ah apent it
Searchin
Fir sumthin
But
Ah seen anither war
And a mither
Weavin a shrood
For the deid man
Still in her wame

Phantasmagoria II

yer lips
is a pink butterflee
flichterin
fae yae wird
tae anither
ah rin efter them
in gairdens
o wheesht

A Photae

(o an Iraqi laddie on the front page o the New York Times)

he sat
at the edge o the truck
(eicht or nine year auld?)
surroondit bi his faimly:
his faither,
mither
and five siblins
wis asleep
his heid wis yirdit
in his hauns
aw the cloods o the warld
wis waitin
on the thrashel o his een
the heich man dichtit aff the swate
and stairtit diggin
the seivent lair

S.H. McGregor

The Last Letter

The Blackhawk helicopter lifted up and away, as though plucked off the dusty landing zone and flung – over top the green palm fronds and grey concrete guard towers – by the hand of God. Corporal Mike Williams, who was buckled inside, strained in his harness to reach the yellow mailbag. It was sliding out the cabin towards the village below, the cargo doors locked open to let in the wind to combat the heat.

The Blackhawk rolled on its side even more, to turn across the village. It was so steep Mike thought they would drop out of the sky. He couldn't imagine what was holding them up. And the mail!

Mike gripped his rifle tight with one hand and reached for the bag. He felt the nylon straps of his harness cutting into his shoulders. His weight strained against the straps; his gloved fingers turned in the mailbag fabric, trying for a handhold. The daily letters to his wife were in the bag, along with mail from the entire patrol base.

The Blackhawk swung overtop Anwar village. As Mike curled his fingers he noticed the mosque tower passing below and the black oblong shapes of enrobed women standing in the market road. If the straps gave out, Mike realized he would fall into the grey empty corner cleared last week by the 500-pound car bomb.

At last he grasped the bag but it was only the edge. The letters inside the yellow fabric spread on the vibrating metal floor of the helicopter. Mike pulled his handhold and the bag slipped open.

White envelopes took flight in the rotor wash, spinning out over the dusty roads of Anwar. The Blackhawk rolled out of the turn and leaned forward, pointing nose down to accelerate. Mike held the bag of remaining letters in his lap, like the Door Gunner had told him before takeoff. But Mike had thought the bag would be all right on the floor. He didn't think the Blackhawk would swing so fast.

Mike looked at the twin Door Gunners, each manning a machine gun leveled at the flowing potato fields below. Their flight suit sleeves fluttered in the wind; their heads, ensconced in aviator helmets, like swollen black pumpkins. It seemed they hadn't noticed the mail. 'But the platoon'll find out. The LT knows everything in that village. And Talley. Fuckin' Sergeant Talley.'

Mike gripped the bag and watched the dusty fields, fallow and dotted with occasional ruins. Like old brown skin, he thought. The lines of irrigation canals like dark veins.

'Now my letters are down there, useless.' He thought of his mornings on guard, watching for the enemy as much as he was wanting Andrea. He spent nights in his tent, writing, writing, and writing. And the patrols – where he was just storing up words to write down for Andrea later. If she never read them, they were like prayers to a false god – lying dead somewhere in dusty Anwar, in a foreign language, meant for a distant address.

'She'll forget me if I don't write,' he thought. She was all that was left of him in the States. If Andrea didn't remember him, believe in him, he was lost to a life outside the war.

'What letters had gone?' he wondered. He opened the sack and tried to look through what was left. 'There should be one for each day, and thirty days since the last mail drop.'

The wind caught more letters and took them flying out the cabin. One of the gunners noticed the flotsam. He turned his black reflective visor towards Mike. Mike grasped the flapping mouth of the bag, trying to show it wasn't intentional. The helicopter swerved. Then kept on course. The gunner pointed at Mike and then the bag. Mike nodded vigorously.

The fields flowed past on either side, screaming with the wind, in the large open doors. Mike kept his back pressed into his seat by tensing his

legs and pushing his heels against the vibrating floor. He patted the side pouch on his armor, checking for his night vision. Then he made sure his Velcro nametape and rank were straight. He felt the safety of his rifle with his pointer finger and touched the infrared laser, fastened on the top of the barrel, making sure it was secure. He pushed his dark Oakley glasses against his face and pulled on the tops of his gloves, one at a time, to make sure his fingers were in all the way.

The fields gave way to a mass of structures, multi-story, sun-bleached and dirt-stained. Black columns rose into the azure sky, extending from some violence, reaching out from the quarry of apartments and roadways. Mike realised this was the city; this was Baghdad.

It was terrifying to Mike to think of these buildings as dwellings, mashed up against one another like stacked bodies. The black windows empty like the eye sockets of skulls and missing teeth. These crevices and corners were threats – vantages for RPGs or rifle fire. Mike's heart started to strum like an electric guitar. He raised his rifle and watched a balcony with his scope. A barefoot man held up his hands, waving to someone or in prayer to Allah, Mike couldn't tell.

Mike noticed a massive turquoise arch. As the Blackhawk came closer Mike realised the arch was made of two tremendous swords, in an eternal cross, each held by giant green hands – reaching up from the earth. Here it seemed violence was larger than life. The sword was supreme. Before, when on patrol or guard, violence was just a mode, an action. But as the helicopter soared over the arch, Mike felt violence loomed as an external force, a kind of tribal god.

The helicopter landed on a concrete pad and one of the Door Gunners waved for Mike to get out. Mike turned the round buckle of his harness and leapt down from Blackhawk. The Door Gunner leapt down too. He grabbed the collar of Mike's body armor, walking him to the edge of the landing zone. He unlatched one side of his facemask and yelled into Mike's ear, above the churning rotor.

'Take… mailroom now. Don't… to piss… stupid shit.'

Mike marched towards a trailer on the corner of the pad, under a camo-net shade. He gripped his rifle in one hand, the mailbag in the other. Inside the trailer was a row of chairs, a desk, and a sergeant waiting near a phone and clipboard.

'Freedom Camp, Sergeant?' Mike asked.

'Bus on the top of the hour, stud.'

'The mailroom, Sergeant?'

'Go across the street, across the parking lot, yeah? Into the Palace, then around the back. It's on the backside, near the pool.'

'I have time to make it there and back, Sergeant?'

'If you fuckin step it out. Range walk, hooah.'

Mike left the hut and walked across the street and into the large parking lot. Since arriving in Iraq, he had never seen so many cars in one place. SUVs and Mercedes sedans and buses. It reminded him of a shopping mall parking lot in the States. And a pool? Mike remembered the sergeant's landmark. Mike thought that that much clean water in one place was a fiction. At the patrol base the men took showers by pouring one liter bottles of water on themselves. To ensure purity the bottles had to be imported from Kuwait. Once, to save money, the army sent them cases of water from up north somewhere. Everyone got the shits. Mike grinned, thinking of the LT screaming in the shitter, cursing hadji-water.

In the far corner of the parking lot a row of humvees waited with soldiers outside adjusting their gear. Mike remembered his brothers back in Anwar, probably on patrol now – and their mail in his hand. He hefted the sack again, and remembered all the letters he had written Andrea. He tried to remind himself what had happened the past month: the events he described and ideas he considered and dreams he shared. But all he could think of was the patrol yesterday, the blazing sun, and the six shots he fired.

'Hey, amigo,' shouted a man in a tan uniform.

Mike stood before a tall concrete gate attached to a bunker. Guards in boonie hats waited behind sandbag positions. There was a door beside the gate. Several civilians in cargo pants and T-shirts were going in ahead of him.

'Clear your weapon,' the guard pointed to Mike's rifle.

'It's empty,' Mike showed his open magazine well.

'At the barrel,' the guard pointed over his shoulder.

Mike noticed a clearing barrel on the other side of the guard shack.

'You don't trust me?'

The guard shrugged, 'Everyone, the rules is everyone.'

'Marines?' Mike asked.

'Peru,' said the guard.

Mike walked to the clearing barrel, pointed his rifle inside, and pulled back his bolt to show his weapon was empty. He realised this guard was a mercenary, not a soldier.

'*Gracias,*' the guard said.

Mike went through the gate and came into a broad wrap-around driveway with green hedges and ficus trees. In the white sun, stood a massive stone building, with rectangular columns crowned with stone eagles. Mike swung the mailbag over his shoulder and began to walk along a path around the palace, looking for the post office.

Around the other side was the pool – just as the sergeant said. And the water was as blue and piercing as a painted Easter egg. And Mike thought if there could be a pool in Baghdad, there could be anything.

The mailbag hung heavy on his back and he continued his walk, watching the diving board standing at attention beside the water. Then he noticed a trailer with a wooden sign: Post Office. He walked inside.

The conditioned air struck him like a gulp of cold beer. Mike stood in the doorway in shock from the chill and trying to allow his eyes to adjust to the fluorescent light, which seemed like darkness after being outside in the Baghdad sun.

'Close the door,' shouted a voice.

Mike couldn't yet see far enough inside the trailer to make out who was yelling. He reached back and shut the door.

'You let all the cold air out,' said the voice.

Mike took off his sunglasses and the room began to come into focus. He saw a gaunt, black-haired soldier behind a counter. It was a private.

'Mail from Anwar,' Mike announced, holding up the bag. He approached the counter. 'I'll just go through it quick.'

'Can't let you do that,' said the private.

Mike began dumping the bag on the counter.

'There's letters to my wife in here…'

The private put out his hands to push Mike away.

'Sholtz?' Mike read the soldier's nametape. 'I have to check for my wife's letters.'

'Addressed to her?'

'Yeah, I wrote them.'

'But if they're addressed to her you can't read them.'

'I wrote them.'

'But they aren't addressed to you. Rule Two: *Only read mail addressed to you*,' Sholtz pointed to a sign behind the counter.

Mike read that Rule One was *Always be on time*.

He shuffled though envelopes, 'They aren't here…'

'These are going in the bin.'

'Andrea Cantor, look for Andrea Cantor.'

'Outgoing mail bin.'

'That's my wife,' Mike saw one of his letters swept off the counter.

Sholtz reached down and picked up the envelope.

'That's mine.'

'It's not addressed to you.'

'If I don't write she'll forget me. It's been six months, man.'

'That's not even your last name.'

'She didn't take my name,' Mike said and his voice almost faltered. Thinking of Andrea now, it seemed she was so far away and disconnected. Mike looked at Sholtz's nametape, fastened over his heart, and then at his own and remembered how proud he was when he was first issued his nametape, black capitals stitched on a grey Velcro strip. And Mike wished Andrea could be part of that pride – that she could be a Williams like him.

'There should be thirty letters in here,' Mike pawed through the remaining envelopes. 'It's been thirty days since the last mail drop. I write every day. But I lost some…'

'If the sergeant comes in and catches you, you're fucked. If I help you and the sergeant comes in, we're both fucked.'

'I need to know which ones I lost – or at least how many. I tell her everything.'

'Rule Three: *Only authorized mail clerks…*'

'Sholtz!' Mike leaned forward. 'Enough with the rules – I wouldn't be here otherwise. I'd much rather be with my team, with my men. But I shot some guy in the face yesterday.'

Mike thought of the dirt alley by the water treatment plant, there was an old chlorine cylinder on the roadside. There was a rustling in the date palm grove, like a rooting hog. A fly landed on his bottom lip, then his nose.

'The rule is you shoot someone; you get a pass – to cool off, so you don't bloodlust. Not really a mail clerk thing, I guess. And if you get a pass, you

get the mail. I lost some…' Mike cleared his throat. 'I lost some of the mail.' He shifted his body armour and looked in Sholtz's eyes. 'I just want to know if I lost anything to Andrea,' Mike said.

'Well, maybe the rules don't mean much to you. But that's the only reason the mail works at all. I'd say it's a miracle you can write a letter in some dump like Iraq and have it sent all the way to,' he paused to read Andrea's address. 'To Fort Walton Beach, Florida. And Rule Four is you tell the sergeant immediately about lost mail…'

Mike grabbed Sholtz's uniform and made a fist to punch him in the throat.

A door in the back storeroom opened and shut.

'Sholtz,' called a voice.

'Yes, Sergeant?'

Mike let go of Sholtz and stepped back from the counter.

'Don't you write anyone back home?' Mike hissed.

There was a shuffling of papers in the back. Sholtz opened his mouth but didn't say anything. Mike looked at the mail on the counter.

'What is it you need?' Sholtz glanced at the door to the storeroom.

Mike didn't know how to answer.

A voice called from the storeroom to Sholtz, 'You finish sorting through the stuff from Camp Slayer that came – oh, Corporal, have you been helped?'

'I was just dropping off,' Mike said.

'You need some water, Corporal? You look pale – don't go passing out in my mailroom.'

'No, Sergeant.' Mike stepped closer to the counter, moving his hands through the envelopes. He didn't see any more of Andrea's letters. 'I just – I might have put the wrong postage on an envelope,' he said, trying to buy some time.

'What is it, standard letter mail to the Continental US?'

'Roger, Sergeant.'

'That's all free. Letters back home are free. No postage required. Sholtz knows that. It's in the rules.'

'There's no more,' Mike said, backing away. He realised there were parts of him that had fallen in Anwar forever, no matter how much he tried; he could not recover everything now. Some things would remain lost.

'Just make sure what's there, gets delivered,' he said, backing towards the door.

'Wait,' Sholtz cried.

Mike turned and saw him waving the white envelope like a flag.

'There's no return address on here,' Sholtz said. 'When you figure that out, bring it back.'

Mike staggered outside, back into the heat of the Baghdad afternoon, with the letter in his hand. He looked at Andrea's address, carefully printed in black capital letters. And it seemed like a place from a movie or novel, not a place he had lived. It was a miracle that a letter could pass from here to there, like Sholtz said. But Mike realised this was all he had left of himself from before yesterday, before the patrol and the enemy in the bushes beside the road. Tucking the envelope in his armour, he decided to keep it to himself.

Basim Furat

Homage to Basho

translated by Abdulmonem Nasser, edited by Mark Pirie

There you are in the presence of Basho,
chanting at the meeting,
and lovingly holding
what others for so long craved;
the fingers of Buddha caressing your soul.
What you look for you shall not find in entirety.
At times you like solitude;
more often you scorn it.
but you celebrate,
filling your memories
with rituals of monks,
who incense their lives
with poems of Basho;
and his teachings and wisdom.

There you are in his presence.
inhale the air heavy with prayer;
and if you wish,
bathe in the rivers of Hiroshima
that run to escape the silence of the mountains.
This silence is the wisdom of Ahiqar.

There you are in the presence of Basho.
Don't forget to pour the water over your hands,
to strike the tolling bell,
and to remove your shoes.
To him, remember your childhood.
When he offers you sake,
tell him about your ancestors,
when, out of clay,
they carved a history that became their imprisonment;
yet, a sail for others.

Inside the roads of a labyrinth,
when the precipice leads towards you,
while you are alerting all of your past,
disregarding the throngs of terraces in your dreams
or forests peeking at the wailing of the ocean,
whisper to the tempest, that it should retire in abashment;
for cherry trees chant to their *nudamai.*
They are the writing fingers of the haiku prince.

Of falsehoods:
You have to cleanse the air,
and adorn the stars in a crystal sky,
with sweet waters the rivers are worthy of.
Trees at river banks are abundant with breeze;
dismiss stray thoughts of the winds.
Refine the day well,
and leave a pleasant memory at every tomb.
There you are,
in the presence of Matsuo Basho

and there they are, fields of withering grass
at the road side,
dreaming of trickling water,
or of two lovers in adoration.

Nudamai – drinking companions

Ahiqar – a sage in Ancient Iraq

A Descendant

translated by Soheil Nasm, edited by Mark Pirie

When I saw my head,
with a beard and long hair,
hung on a spear,
I shaved,
cut my hair,
perfumed
and went out
to court the women of
the city.

Did I delude myself
that I wasn't the one in the picture,
whose head hung from a spear?

Freedom and Exile

Hussain Al-Mozany

interviewed by Jennie Renton

Iraq is a country rich in history and culture, a country that continuously sought and found new forms of expression, a country that laid the basic principles of the Western and Eastern worlds. It was the country of trade that invented the written language; it was the country where poetry, storytelling, numbers, mathematics, astronomy, medicine, art, music, laws, and myth began; it was the origin of religious scripture, the cradle of the prophet. But despite these material and intellectual riches, Iraq has become a country of chronic suffering. Its people lack basic resources; massive human rights violations and matchless repressions abound; armed conflict, sanctions, looting, and environmental destruction are the order of the day; its people have been traumatised through terror, forced into flight, and killed in senseless static warfare. Though Iraq can boast of a great diversity of identities and languages, it has remained a place of bloody ethnic and nationalist confrontation.

(Hussain Al-Mozany, 'Democracy Dictated', www.eurozine.com)

What age were you when you left Iraq in 1978?
I was twenty-four, and an open critic of the regime. I left thinking it would be only for a short while but I have been in exile for over thirty years. First I went to Lebanon, where I managed to find work as a journalist with Arabic-language newspapers in Beirut; then in 1980 I moved to Germany, which has become my home. I am a journalist and writer. After years of writing in Arabic, my most recent three novels, *Confessions of a Butcher*, *The Marsh-Dweller* and *Mansur, or the Allure of the Occident*, were written in German.

And you're also a translator, from German into Arabic?
Yes. Among the work I've translated are books by Robert Musil, Günter Grass. I have also translated stories by Rainer Maria Rilke, whose prose work was previously little known to people in the Arab.

Where was your home in Iraq?
Maimuna. It's a small place – you won't find it on the map – it's near Amarah, in the southern marshes. My whole family comes from there. We moved to Baghdad in the 1950s.

Was storytelling an important part of your childhood?
I learned from my parents many, many stories about the people of the marshes. But my parents and my grandparents were 'un-alphabeted' – they could not read or write. In fact my father went to school at the age of forty, just to learn letters, and he motivated me to appreciate learning. It was at school in Baghdad that I discovered the beauty of Arabic letter-forms. I found myself fascinated by the language. Arabic is not my family's language – in southern Iraq we had our own dialect.

Your family obviously felt a great sense of loss at leaving the south. Was that in a sense, the first exile?
Yes, and not just my family, but for the thousands of similar families who moved to Baghdad at roughly the same time. We all lost everything – the marshes, our identity, our language, our land. Most of us ended up in Sadr City, an area of Baghdad built to house this influx of people from the south, I think with the intention of keeping them separate from the Baghdadis. My parents still stay in Sadr City and the situation there today is terrible.

In the marsh region, what sort of way of life did your family have?
Our people were shepherds and they worked the land, not farms but smallholdings. The extended family lived together and shared the work. But it was a very hard life, that's why they left. And as a small boy I was of course excited about coming to live in Baghdad, which was a very beautiful city. My parents found jobs as hospital workers, I started to attend school, learned to read and acquired books of my own for the first time. I loved reading and by the time I left the country I had a lot of books. As a young man in Iraq I used

to talk openly about literature and art and ideas with my friends. But as the regime became more and more oppressive, we knew we might have pay the price – and I was one of those that did. Later in the Lebanon a whole new world of writing opened to me, of books which had been banned in Iraq. It was in Beirut that I first read Joyce, Hemingway and Eliot.

In the West the only images many people have of Iraq are of a war in which the arts and the artistic heritage have suffered collateral damage.
It shoud never be forgotten that Iraq has a literary heritage that stretches back 7,000 years – ancient Mesopotamia was a wellspring of civilisation. And after Iraq became part of the Islamic world it was the centre of Islamic culture for 1,400 years, with universities in cities like Baghdad and Basra becoming great centres of learning.

Iraq contains many different cultural and ethnic groups…
This diversity makes up the real Iraqi culture. The country has experienced long periods under colonial rule but in 1921 the borders were set as they are today and in the decades that followed there was a cultural renaissance, led by internationally renowned poets such as Muhammad Mahdi al-Jawahiri, Ma'ruf al-Rusafi and Jamil Sidqi al-Zahawi. Then in the late '40s there came a new wave of progressive, experimental poets who revolutionised traditional forms: Badr Shakir al-Sayyab, Nazik al-Mala'ika and Abd al-Wahhab al-Bayati inaugurated a new age in Arabic poetry – and their influence was by no means confined to Iraq. Nor were the interests of Iraqis readers inward-looking – in as far as they could, they engaged with literature from around the world.

What happened to the books you left behind in Iraq?
My mother feared that the police would come and find my 'forbidden' books – and so she burned every book I possessed. I remember the day before I left my grandmother telling me that she couldn't bear the thought of losing me. I said to her, it's just one person you're losing but I'm losing everyone, my family and all my friends. I didn't go back to Iraq again until after Saddam Hussein had fallen. That was twenty-seven years later, by which time my grandmother was ninety-six. She asked, 'Do you remember what I said to you when you left? How I couldn't bear to lose you?' The sense of loss had endured for both of us through all these years.

Hassan Abdulrazzak

Fairytales

All this should have been written down much sooner.

I was on holiday in Cyprus when the Iraq-Iran war broke out. I ought to preface this by saying I was seven at the time, no one had tipped me off or anything.

My parents had returned to Iraq towards the end of summer as they had work to get back to. As I was enjoying myself, digging tunnels in the sands of Cypriot beaches and learning to swim with the aid of inflatable armbands, they decided to leave me in the company of my paternal grandmother and uncle. They were convinced, mistakenly as it transpired, that swimming might help me to shed some weight. I would look out occasionally at the sea, with its enthusiastic backslapping waves, before returning to digging for the lost treasures of Atlantis.

Big. That's almost all I remember of my grandmother. Of course I was seven, as I already said, so this size-biased description is questionable. Yet in my memory, none of the other characters: mum, dad or uncle could be described as unusually big. My grandmother, who now only exists in fading photographs, seems to me – as I try to summon her – a woman of enormous stature. A gentle giant with a fondness for floral pattern dresses.

Grandma and I were due to return to Baghdad on the day the war broke

out. We didn't plan it this way of course. No one knew that a war was about to start or perhaps the adults knew and didn't tell me. At any rate my uncle, who followed politics closely, must have thought we had a good chance of catching the flight home. After a light breakfast, Uncle's preferred Greek driver bundled us inside his black Mercedes Benz. We set off for Larnaka airport at the hour before dawn. I knew the route was beautiful because I had looked out of the window all the way from Larnaka to Paphos at the start of the holiday. Now everything was covered in darkness so that the trees looked like monsters guarding the occasional tucked-away *taverna,* or like soldiers standing shoulder to shoulder along the winding road.

We got as far as the departure lounge. Grandma sat next to me, her nervousness growing and becoming infectious.

I see a glass door in the lounge looking out onto the runway and our stationary Iraqi jet, with its characteristic green fin, standing there before us within walking distance. A picture too neat to be entirely plausible.

I think I burst into tears when Grandma told me the aeroplane wasn't going to take off that morning, or any other morning, and that we had to go back to Paphos. My uncle opened the door of his hotel room, his hair messy from sleep, to see his anxious mother holding the hands of a seven-year-old tearful boy, her grandson, his nephew, a responsibility he didn't ask for but would have to take on nevertheless. He laughed, gave me a pat on the head and told me not to worry.

I don't remember the flight to Cairo where Uncle resided. And I don't remember much about how I came to be enrolled in a private school in the posh district of Zamalek. But that's what happened. Occasionally my parents would call from Baghdad. I would strain to hear their voices through the crackle of the bad lines. It was like receiving calls from beings in a parallel universe. I began to doubt, ever so slightly, as time passed, that Baghdad really existed. Perhaps I had dreamt it up. The memories of a child are muddy paths, not asphalt highways. The possibility that you had understood something incorrectly always loomed large. Iraq, therefore, could have been the product of my overactive imagination.

This imagination had partially been nurtured by Grandma, who was now my only link to this other world inhabited by my parents.

In Baghdad I had slept in the same room as my parents. Grandma had her own private bedroom, which she first entered as a young teenage bride.

Grandad had died of a heart attack in the mid '60s, leaving her his side of the bed. No one else came to share it with her. No one was expected to. In Cairo, she had to share a room with me in Uncle's spacious apartment. At night the room was bathed in red light, like a burlesque brothel, courtesy of a psychedelic lightbulb shade, a left-over from the '70s that my uncle didn't bother to update. I am tempted to describe the light as being garish or vulgar, but a red room to a child is nothing short of magical. I concluded that this must be one of the major differences between Cairo and Baghdad. In Cairo, red rooms exist.

Grandma and I often stayed up at night playing cards. Occasionally she would tell me fairytales, many of which were by now familiar, as I had heard them throughout my childhood. I would beg her, 'Grandma, tell me the story of Layla and the Wolf. Please, Grandma, please.' She would happily oblige but I often listened with a sense of disappointment. Somehow the story was better when she told it in Iraq. I would try to pinpoint the missing ingredient. Was it the tone of voice; the lacklustre build-up to the climax when the Wolf tells Layla he will eat her up? Or, as Grandma put it, quoting the wolf but no longer imitating his scary voice as she had done in Baghdad: 'I'll cut a chunk of meat from your forearm and put it in a sandwich.' I stopped asking her for stories and began to read comic books instead.

School was hell. Dusty playground. Overcrowded classrooms. Hostile pupils. Heavy beatings by teachers who must have read Dickens in their youth and mistook it for an exemplar on teacher conduct. And all this at a private school! Even at the age of seven (slowly approaching eight), I knew that private schools were meant to be superior to government schools. As I sat alone at the front of the yellow school bus on the way back home, I would look out of the window at the children from the government schools and wonder how bad it was for them. Perhaps they were taught by witches with broomsticks and ugly warts. Warts bigger even the one on the right cheek of my grandma. Maybe they were sacrificed on Aztec altars like Tintin nearly was in one of his adventures, or perhaps every morning they were trapped in the school courtyard and cannibals set loose on them. The last fantasy filled me with dread, as I knew the fat kids would die first.

English was my most hated subject. Who invented this odd language? Sentences that run perversely against nature from left to right. Unpronounced letters lurking in the middle of words unnecessarily, wreaking havoc like

school bullies on earnest students trying to spell. As for grammar, forget it. They teach you one rule, you get your head around it then they teach you ten or more exceptions to it. Hopeless. No wonder God spoke in Arabic.

One time, I had some English homework to do. Copy out a few pages of text. Simple. But by the time I got through my Maths, History and Arabic homework, night had set in and I was feeling sleepy. I whinged to my protector giant who watched over me in hostile Cairo. 'Come on, Grandma, it's easy. You look at the words in this book, this book, this book Grandma! Pay attention. And then you copy the words to this blank page in the exercise notebook. What are you doing? You can't use a pencil! Why do you want to use a pencil?'

But she insisted. In the end I conceded and let her do my homework with a pencil while I slept.

In the morning, my exercise book was laid out on the dining room table. She had copied more than was required. Each letter was pressed into the exercise book as if it had been poured out from a receptacle containing freshly melted lead. I traced my fingers against the letters and was alarmed by their easily perceptible texture. It was as if she had carved the letters rather than written them. It reminded me of Sumerian tablets I had seen in some book or other. I felt guilty as I imagined her staying up late into the night copying out my homework, one painful letter after another. A slow trudge up an impossible mountain, requiring the patience of a devout believer, someone capable of reading the Qur'an from beginning to end to ward off the evil eye every time her grandson became ill.

I was irritated with her for making such an enormous sacrifice for nothing. The teacher was bound to know this was not my handwriting. Moreover she had copied out the letters of the words individually rather than joining them up as was required by the school. Where she had made mistakes, the paper had been rubbed so vigorously as to render it almost transparent. I knew I would have to do the homework again. Why didn't she tell me her handwriting was so peculiar, or that English was an alien language to her? These were my thoughts at the time. Although she had often told me the story of how she was taken out of school by her parents at the age of twelve or thirteen (as often happened to girls of her era), I had no appreciation of what that meant: her handwriting freezing forever prematurely, never acquiring the polish of an educated adult's.

She was a gentle giant. She watched over me and consoled me when I received a poor mark or when a phone call from my mythical parents awakened strong longing.

Then one day, my dad appeared at the door. The mythical world suddenly collided with the real.

I ran into his arm, flooding with happiness. Like the fictional Moses I watched in Egyptian religious soap operas, I was glad to leave Egypt.

I remember the day they told me she had died. I was playing with toy soldiers. I must have been ten or eleven. It was a cloudy, late summer's day in Prague's district ten. By that point, Iraq was rapidly becoming a mythical memory for thousands of fleeing Iraqis. A place where cannibals devoured the young in peculiar ways by sending them into battle with the young of Iran, another mythical place with its own set of cannibals. Our cannibals were slightly prettier, as they had moustaches, whereas theirs possessed thick, shaggy beards. Many Western countries also thought that our cannibals were more presentable, which is presumably why they gave them the better spears. My mother walked into the room and announced the news of my grandma's death in a calm but grave voice. I put my toys down and listened. I was silent for a moment, then I resumed playing. I waited for the tears to come but they never did.

In Baghdad, before the war with Iran, before Cyprus and the hated private school in Cairo, in a time that I can no longer fix to a particular year, my grandmother told me a different version of the Layla and Wolf story.

Layla was in the kitchen of her grandma's house and there she was confronted by the Wolf. I think they had the usual conversation about his long teeth and sharp claws. Then came my favourite part: the Wolf threatening Layla with the possibility of turning her into a sandwich.

'I'll cut a bit of your...' My grandmother paused. 'Go on, Grandma,' I said, puzzled why she had stopped. 'Go on,' I egged her on.

'I'll cut a bit of your cunt and stuff in a sandwich. And then I'll eat it!'

I think her face lit up with mischief as she said this – or have I added the mischievous look over the years to make sense of the peculiarity of what she said? Did she say the line in a normal tone or with a scary, wolfen voice? And what word did she use? Was it really *kus* (the Iraqi word for cunt), or did she

use something more conservative? No, I am sure it was *kus* because that was the first time I truly understood what the word referred to.

And here is another pre-war memory:

Mid afternoon. My parents at work. My grandma encourages me to do something to our servant, an illiterate woman named Alya.

Alya was forbidden from bringing men to her room, which stood at one end of the garden, reeking like a kennel of something animal-like. Even Alya's husband was never allowed to stay for more than a few days at a time. Grandma was relieved when he joined the army and disappeared.

I remember Alya lying on the ground that afternoon, her dishdasha dress pulled up to her breasts, her brown belly before me like a drum and my grandma goading me to touch it. And I do. And to this day, I remember what that touch felt like. And to this day, I am turned on by a woman's belly more than any other part.

My grandma is in the room. Another time. Another afternoon. Which room? Not her bedroom I hope. Her mother, my great-grandmother, is there also. A tattooed, ancient being dressed head to toe in black. Two white braids hanging down to her midriff. My great-grandmother takes out one of her breasts, shows it to me. She then squeezes it. A drop of milk pops out of her nipple and rolls down the wrinkled folds of her skin. How can that be? She must have been in her seventies or eighties. But there it is, clear and sharp as any image I've ever seen. A drop of milk on the breast of my great-grandmother. She tells me not to be afraid to taste it, to go on and taste it. And all that time, my grandma, her daughter, is standing over us. Watching me as she always did.

What do you do with such memories?

Shampa Ray

Oasis

Where was my Babylon?
I lived there once
We took the road through Mosul.

Was it under the sky?
where the bombs ripped
my still-hanging garden?

Where was Ali Baba
whose thieves stole a secret
in the wink of an eye:

my year in the grip of desert?
Baghdad was my city,
greener and wider than sand.

Once there were tanks,
thirteen toys on a bridge.
Eucalyptus waved its flags.

Where was my oasis
hung from chains in the sky?
Gone to ground, to ground.

Radhika Dogra Swarup

By Any Other Name

Sally puffed her cheeks out against the heat and turned to look at her daughter. Alice was standing on tip-toe with her flimsy battery-operated fan held close to her cheeks. The effect was negligible, and the girl's face flushed a deep red.

'Why are you standing like that?'

Alice blew hot air through rounded lips. 'They said at school that it gets cooler the higher up you go.'

Sally laughed and ruffled her daughter's hair. It was damp at the roots, its blond fluffiness dank and dark in the heat. From the opposite platform, she heard the noise of a baby crying. A woman walked on, pushing a pram. She bent down towards her baby's face, and in the still of the platform, Sally could hear her cooing to the infant in pleading tones, repeating her words liltingly in the hope it would fall asleep. She thanked God that Alice had outgrown her semi-conscious phase. She wasn't sure she could have managed with the inconvenience of a baby and a pram in this heat.

Still, a conscious child meant its own problems. Alice had moved the fan closer to her face while her attention had been distracted, and Sally snapped at her. 'Don't, Alice, or the fan will eat up your hair.'

The girl giggled at the thought, and coquettishly straightened her hair

out over her shoulder. 'But it's wet, Mum. Here, touch it. It's so hot!'

'I know, darling. We'll be home soon, and then you can have a nice ice lolly to help you cool down. Would you like that?'

She nodded, and moved the fan marginally further away. Suddenly, a gust of wind blew their way from the train tunnel. It was strong enough to force Alice back from her tip-toe. The air it brought with it was hot, hotter even than that they had been complaining about. Still, in the underground stillness, the very movement heralded relief. Sally took her daughter's hand.

'Come, darling, the train's almost here. Not long till we're home now.'

The train came to a shuddering halt, and the carriage doors opened. Sally waited for the passengers to get off. They were the usual inhabitants of weekday London: tourists, students, pensioners, young mothers. And then there were those she always wondered about: the man in the dark suit with a lean briefcase; the middle-aged woman who fought against Tube convention by trying to establish eye contact. What were their stories? Was the man a businessman in town for the day? Was he an out-of-work salesman trying to busy his days in travel, and did his family know of his problems? And the middle-aged woman who tried so hard to elicit a response, what was in her past? What loneliness lay there? Sally always checked herself when she caught herself in these flights of fancy, smiling ruefully at the pessimistic tilt her thoughts invariably took.

They entered the carriage. It was empty save for an elderly man who crouched against a corner, and Sally settled Alice down before sitting beside her.

The man nodded at Alice, who smiled at the attention. She turned her fan on again, and brought it near her cheeks again.

Sally repeated, 'No Alice, remember your hair please.'

'Will the fan really eat it up?'

'Yes, darling. And we wouldn't want that, would we? It would be such a shame if you lost your lovely hair.'

The man clucked at this, offering the child a smile. Alice looked at him with big eyes, and in response he widened his, extending his lips out into a comic face. He noticed Sally looking at him, and immediately his smile grew muted, and he nodded again before looking away.

Alice tugged at her mother's arm. 'I do have lovely hair.' It was said in a matter-of-fact fashion, the words spoken without egotism, almost without awareness. She brought her fan away from her cheek, and blew into it. The

blades stuttered for a moment, then carried on with their anaemic motion.

Sally looked back towards the other passenger and saw him looking at her. This untoward intimacy irritated her all of a sudden, and she turned her head away. He turned his attention to Alice, who was still blowing into the fan.

'Have you had a nice day out?' he asked in a spittle-filled voice.

Alice nodded half-heartedly, her attention focused on sabotaging her fan's action.

'Would you like a sweet?'

Out came some old hard-boiled sweets in fraying covers half-coated in lint and paper from the man's pocket. Alice made to move, but Sally stayed her. 'No, darling, remember the ice lolly waiting for you at home.'

The girl shrugged and returned to her efforts with the fan. The old man tried again, 'And where's your daddy?'

'In Iraq,' said the girl.

The man took up a slow, arthritic clap that only let up when Sally looked across at him. 'Brave man, your father,' he said. 'A real hero.' And in a conspiratorial tone of voice, he added, 'Fighting against all that Muslim scum.'

Sally considered responding, but the man opposite was looking at her with such bright-eyed concentration that she considered it wisest just to look away. There was a newspaper on the seat next to her, and she turned to it instead.

The front page was full of sensationalist headlines – news of bomb plots foiled, terrorists detained – their tone half-laudatory and half-alarmist, as if wary still of unrecognised dangers. A picture of a man accompanied one of the articles, and she opened the paper out to see him in full. The caption below the photo hailed him as one of the most dangerous religious extremists in Britain. He wore Islamist clothing – a loose, white robe, a skullcap that clung to his crown – and he had a beard that ran down to his chest. And yet, despite his adherence to the conventional image of a hate preacher, Sally sensed a vulnerability in him. The photo looked like it had been taken outside in the summer, perhaps at a picnic or a wedding, and he wore an uncomfortable smile borne of overlong posing. Sally wondered if he had shaded his forehead as he smiled at the camera, for a subtle shadow rested briefly above his mouth before losing itself in his beard.

She looked up to see the old man studying her still. He cocked an eyebrow at the headline and waited for her reaction. She said nothing, and he spoke, 'There's graffiti on the street near my house. You know what it says?'

She frowned, but remained silent.

'Pay for Iraq.' He drove his index finger into the air, and repeated, 'Pay for Iraq, it says. Can you believe the ingratitude?'

She hastily put the paper down and looked steadily in front of her.

'You just can't help some people.'

The train slowed, its chugging grew louder, and they approached the next station.

Alice had tired of blowing into her fan. She tapped on Sally's forearm and asked, 'Are we there yet? It's hot. And I'm thirsty.'

'Not quite yet, darling, you can have a drink of water as soon as we're home.'

'But I'm thirsty now.'

'Not long to wait. A cool glass of water with lots of ice in it.'

'BUT-I'M-THIRSTY-NOW!'

'I know, darling, but we have no water left. Just wait a little while.'

Alice's face grew redder, her flush extending up to her hairline. She looked like she was considering her response. At quieter times, Sally loved this fleeting transparency to her daughter's moods – she loved watching her teeter between understanding and sullen selfishness. Now, in the heat, she hoped Alice would choose to be reasonable.

The other passenger spoke, 'I have some water.'

He took a half-full bottle of Evian out of his bag and held it towards Alice. She jumped out of her seat and was making her way across when Sally stopped her.

'Aren't you forgetting something?'

Alice turned towards her with a frown.

'You're not supposed to accept anything from strangers.'

The man spoke again. 'It's alright, really it is. The child's hot and I have water. Please just take it.'

Sally shook her head, still addressing her daughter. 'Come back to your seat, please Alice. We'll be home soon.'

The girl heard the warning in her mother's voice and walked silently back. She rested her head against the glass partition by her seat, and looked

listlessly at the metal floor as it jostled to the train's approach.

The train came to a stop, and two people entered the carriage – a man with a young child. The child walked in first, taking long strides with her slight legs, and jumping onto the corner seat opposite Alice's.

The man's movements were more measured, and when Sally saw his face, she instinctively glanced at the newspaper to make sure he wasn't the smiling extremist whose photo she had just been looking at. He too was dressed in flowing white robes, with a white cotton cap fixed to the back of his head. His beard gave him away though, it was darker, much more luxuriant than the one in the picture she had seen.

The girl with him was studying Alice closely, watching her with interest as she blew hot air into her fan. She turned to the man with her, and in a brisk English accent, said, 'I'm hot, Baba.'

'Then stop moving around so much. You'll be much more comfortable if you calm down.'

She frowned at that, then shifted to lean against him. Her head came halfway up his torso, and slowly she put her tiny, tanned palms around him.

'Mmm, you're nice and cool.'

'That's because I'm not a restless little thing like you.'

His accent was foreign, Sally thought, and as he laughed at the girl, his inflection deepened.

The girl snorted in derision. She began to scold him in her bossy girl's voice. 'But Baba, I'm staying still now, and I'm still hot. I'm all wet. Why aren't you hot and bothered?'

'Because I don't wear jeans like you.'

'What's wrong with my jeans?'

'They're tight, you see. Not right for this weather. I'm never hot because I'm dressed in loose fitting clothes – they're modest and practical.'

The girl looked down at her jeans. They were a fashionable stone-washed blue, adapted for girlish fancy with glitter detail around the pockets. 'But I like my jeans.'

The man was silent. Sally noticed the elderly man looking at her intently, and once he caught her eye, his eyebrows rose high.

'But I like my jeans, Baba. They're pretty,' the girl repeated, and now the old man's reaction grew vocal in the form of a loud cough.

'That's fine if you're happy to be hot and sweaty.'

'Will I really feel more comfortable if I wear loose robes?'

'Of course you will. Feel me, am I sweating?'

She raised her hands up to his chest, feeling for moisture. Next she lifted herself to rest on her knees, and felt his neck, then his cheeks. Finally, she dug her hands into his beard, fingering each strand individually in her search for discomfort. She buried her face into his beard, and giggled. The laugh sounded hollow through his hair. After resting a while, she spoke from its shelter.

'Ok, you win. Can I wear a robe like yours?'

'You'll have to wear one like Mum's. Would you like that?'

The old man got up from his seat, and walked to where Sally sat. In a loud voice, he asked, 'Are you done with that paper, love?'

She nodded silently, and passed it to him. He made his way back to his seat, talking all the while in his new loud voice, 'Want to find out what's wrong with the world today. See what the terrorist scum have been up to.'

The bearded man looked up at the direction of the noise, then turned to Sally. She quickly averted her eyes, moving to scold Alice noisily for causing potential damage to her fan.

The old man began to comment out loud. 'Another bomb plot.' A pause, then, 'All these people.' Another moment, another snippet read, and with a shake of his head, 'The country's not safe anymore.'

The little girl spoke, 'Yes.'

'Yes what?'

'I'd like to wear a robe for the heat.'

Alice switched her fan off and asked the man with the flowing beard. 'Are your robes really very cool?'

He waited for a moment, looked up at Sally, and then, in the absence of an interruption, said, 'Yes, they are.'

Alice turned to her mother. 'Can I have robes to wear too, Mum?'

The old man coughed again, and said, 'Lunatics these people are.'

'I think they look cool. They're a bit like the robes Harry Potter wears.'

The old man looked at Alice, and stretched his lips out in invitation as he had done earlier. 'No, love, you don't want those robes. They're not for a lovely little English girl like you.'

Alice looked at him with wide blue eyes, and then looked up at her mother. Sally bent down to take up her hand, and squeezed it hard. Her

daughter spoke softly to her, 'But the other girl's English too.'

'I know, darling. We'll be home soon.'

The man had put his arm around the girl, and she nestled in closer to him. She still sat on her knees, with her head resting against his beard. Now she raised her hand to his beard, and gently stroked it. She repeated this motion for a few minutes, starting at the top of his cheek and slowly raking down to where it thinned by his chest. The train shook them steadily, and with the combination of the girl's touch and the heat, the man's eyes began to droop.

The girl let him sleep for a while, slowing her motion as he rested, then all at once, raised her index finger to his cheek to tickle his beard. He got up with a shake, confounded by the sensation and by his spontaneous midday rest. He looked at the girl as she buried her head further into his beard to hide her giggles, though they reached them all in their hollow, slightly other-worldly mirth.

'You naughty thing!' He laughed, tickling her back, and again Sally was struck by how foreign his intonation was.

The girl lifted her head. 'I'm hot, Baba.'

'So what can I do?'

'And I'm thirsty too.'

'That problem I can solve. Just wait a minute.'

He delved into his bag and brought out a bottle of water, which he handed to the girl. Alice, deprived and impatient, took the opportunity to restart her supplication. She said loudly to the carriage, 'I'm thirsty too.'

'Not long to go now, Alice.'

Her voice grew hysterical. 'But I want water now.'

'I'm sorry, but there's nothing I can do about it. You're going to have to wait till we're home.'

The man reached into his bag and brought out another bottle of water. He said softly to Sally. 'I've another bottle of water if your daughter wants some.'

The elderly man spoke again, his voice raised and slow in its emphasis. 'Now remember what your mother said to you, love. No taking anything from a stranger, do you understand?'

The man looked for a moment at the adults, and shrugging, put the bottle back into his bag. He turned towards the girl, and nestled her against him again.

Sally remained silent, her gaze focused on the train floor. The tannoy came on announcing their stop, and she took Alice's hand in hers. 'That's our stop coming up, darling.'

She rose, and as she did, she noticed that the little girl had started stroking the man's beard again. His eyes were open now, staring past her, beyond the carriage out of the window. As the train moved, his eyes flickered back and forth to the changing scenery.

The train began to slow down, and the man looked briefly up at her before glancing away. She turned to go, and then, as the station came into view, she looked back at the old man with his bright eyes fixed on her, and next at the robed foreigner scanning the scenery with vacant eyes. She said, 'If you don't mind, sir, could we have that water after all? My daughter really is very thirsty.'

She could hear the old man cough violently, but she refused to look at him. The train stopped, and the carriage doors pulled open. The man reached into his bag and offered the water to her without comment.

She took it, and as she moved towards the exit, said, 'Thank you. That's very kind of you.'

He nodded slightly, but didn't say a word in reply, and she stepped out of the carriage. As the doors shut against them, she paused to give Alice the drink. The train began to pull away, and her carriage went slowly past. The little girl in jeans peered out at them from behind the thick train window, and as the train gathered speed, she saw the old man look at them too, his mouth stretched thin and painful again, his look materially the same as the comic face he had tempted Alice with earlier.

Abd Al-Wahhab Al-Bayati

The Master and His Disciple

translated by Salih J. Altoma

I

In Baghdad in the District of Bab al-Shaykh
my master, Shaykh al-Kilani,
opened the door to his anonymous
visitor and said: I know whom you seek
but my offspring was banished
to the seven cities of love; he vanished
into the Milky Way.

Whenever he visited his relatives
in Baghdad, he visited me
to relate what he endured in his exile
or to ask me what I thought of his verses.
At times he wept in distress,
like a man who lost something,
he took refuge in the Mosque's sanctuary
reciting verses from the Qur'an.
at times he beseeched a woman who had departed or passed away
searching for her in the poetry of al-Shibli and the *Tawasin* of al-Hallaj

2

On the last day
he kissed the window of my tomb
and whispered:
Farewell my Shaykh
and was gone.

What is Baghdad now
but a graveyard of his loved ones
and a love poem that has vanished?

Notes

Abd al-Qadir al-Kilani (al-Jilani) (1078–1166) is the founder of al-Qadiriyyah, perhaps the oldest mystic Sufi order in the Muslim world. His tomb is located in Baghdad in the district of Bab al-Shaykh where Abd al-Wahhab al-Bayati was born and raised. The title of the poem in Arabic is 'Al-Qutb wa al-Murid', literally 'The Pole and the Novice'. In Islamic mysticism al-Jilani is generally called 'al-Qutb', or 'the supreme pole', the highest rank in the mystical hierarchy.

Al-Hallaj, a leading mystic who was executed in Baghdad in 922, is one of al-Bayati's central historical figures, which he invokes in dealing with contemporary sociopolitical issues. *Tawasin* is the title of one of al-Hallaj's books which al-Bayati addressed earlier in his poem 'Reading al-Hallaj's Book of Tawasin'. The poem has appeared in several English translations one of which was reprinted in Jacques Berque's *Arab Rebirth: Pain and Ecstasy* (London: al-Saqi, 1983). Al-Shibli (861–945) another noted mystic who was al-Hallaj's associate for some time, is said to have testified against al-Hallaj before he was executed.

Keith Aitchison

Immediately Before the Incident at Marqab al-Amir

I don't know how it happened... *I don't know how it happened.*

In the unending racket of a Warrior APC shuddering across bare desert, no music playing in the cramped troop compartment can ever sound as the artist intended.

Skinner had picked Joe Cocker's cover of *Summer in the City* for irony – our being sent to Camp Dogwood, far north of our usual haunts in Basra – and next was our new Rupert's, which turned out to be Dylan's rock version of *All Along the Watchtower*.

'That's how Marqab al-Amir translates – Watchtower.' Campbell already seemed the sort who believes strongly in educating his squaddies above their station. 'The Emir's Watchtower. Khalid says it's very old, worth seeing for itself.'

But not being new, our thoughts were not on the past.

'*Our Boys in the Triangle of Death.*' Pallid beneath the Warrior's muted cabin light, the Dog was peering at a four-day-old newspaper. 'Says here we're a' heroes.'

'You think you're a hero?' Ollie snorted derisively.

Wherever Campbell went, Ollie came, watchful, in his shadow. Our last

lieutenant had walked into an IED in Basra and now lay filed away with those other broken soldiers who'll never march again. Rumour was that the colonel had made it very clear to Ollie that his chances of promotion beyond platoon sergeant rested on this latest Rupert remaining undamaged.

'Are heroes allowed tae be feart?' the Dog asked innocently.

'Of course,' Campbell nodded vigorously. 'Fear's natural.'

'Then I'm a fuckin' hero all right.'

'What's with this *Triangle of Death* shite?' Whitey had the paper now. 'Are they invitin' a pop at us, or what?'

We were quiet after that, Dylan and the Band struggling to be heard as our tinny stereo squirmed on low battery against engine growl, clattering tracks and the recycler's nagging whine. But, exhausted after nights without real sleep, nothing could stop me dozing, if only a few scattered seconds between jolting sickly awake to taste again the clammy, re-used air of this claustrophobic steel hull, its hot reek of sweat, diesel and burnt cordite.

Slow and cautious, our little convoy of armoured steel and tired squaddies grunted tediously across stone and sand, halting at a line of silent pylons staggered across the empty plateau, iron ribs broken and bent, power lines severed and loose. We debussed thankfully, let the sun work on our damp shirts, breathed clean air while the wary sappers in the Warrior following ours brought out the mine detector and did their painstaking stuff once more. No mine, no IED, false alarm yet again; we heaved off once more towards the heat-blurred horizon.

'How far?' Flagging now, his Sandhurst veneer rubbing thin, Campbell turned wearily to Khalid, the earnest interpreter and guide loaned us by the US Marines.

'This speed, maybe one hour.' Khalid closed his eyes and rested his head on his hands, where it shook along with the rest of him to the Warrior's grinding rhythmns.

'The base at Marqab any good?' Whitey inquired.

'Not good. Small.' Khalid did not open his eyes.

'Has to be better than bloody Dogwood!'

'Yes – no missiles every night.'

'Something more to wash in than a bucket?' I asked hopefully.

'Maybe even a thunderbox?' The Dog had just finished yet another excruciating bout of the runs.

The Warrior lurched into a sudden valley besieged by swollen tides of red sand. We took turns at the periscopes as the desert plateau dipped towards arid fields veined by dry irrigation ditches and chequered with untended clumps of sickly date palms. One stand of trees had been fire-stripped to blackened trunks; others struggled for life, long pendants of shrivelled dates drooping beneath yellowed fronds. We saw none of the tethered goats or roaming sheep we had come to expect around Iraqi settlements, no donkeys carrying impossible loads, no startled people turning to stare apprehensively at our approach.

The empty village was the usual straggle of dun-coloured buildings and courtyards, little different from all the others except for its collapsed roofs and shrapnel-scarred walls. Beyond, a slight rise was crowned by a circle of greyed stone, the Stars and Stripes flying above an empty gateway.

'Made a real job of this place,' Skinner said pensively.

'Skinner,' Ollie was at the other periscope, 'your side – that field off to one o'clock, where the tracks meet – left-hand corner – see him?'

'Old guy, head bent over. He's not looking our way. Seems to be working, clearing the ground, maybe. Deaf and half-blind?'

'Or maybe he's pretending he's no' looking our way.' Ollie turned to Campbell. 'We should pay a visit, see what he's up to.'

Campbell came back to the periscope.

'Seems harmless, and we'll be deploying to check the village – can't spend resources on one old man all alone in a field.'

'If he's dicking us, could be an IED up ahead.'

'That's why we're deploying,' Campbell had the certainty of rank; Ollie gripped the periscope very tightly, said nothing more.

Debussed again, the temperature a mere 28C, holiday weather, far distant from sweating out Basra's steaming humidity among broken sewers and rat-crawled refuse, Marqab almost peacefully welcoming in its empty silence – until we caught a stink of decay clinging like some bad memory among the smoke-stained ruins.

A withered courtyard garden was so long dead of thirst I could not tell whether it had borne flowers or fruit, its little broken house still showing traces of the inhabitants, one wall holding ornate and charred Arabic calligraphy – the Qur'an, I thought – another with a cheerful and younger Saddam waving to his loving people from a twisted metal frame. A pair of tattered

leather boots lay untidily among smashed glass and burst furniture, next to them a hank of cloth, perhaps a woman's scarf, once bright and attractive, now filthy and torn. Then, the head of a child's doll, bleached plastic eyes staring at a sunlit wall and its shifting stain of greasy black flies. It all made me coldly uneasy, even apprehensive, but for a soldier, debris and dirt must be just that, nothing more, so I turned my back and went forward, looking for possible IEDs to raise the sappers' blood pressure once again.

Nothing.

Campbell and Ollie led us and our four Warriors up the rise towards the US flag on the battered stone rampart, Ollie fiercely watching to make sure we made an effort to appear properly soldierly under the eyes of our Yank allies waiting by the gate.

'US Marine Corps Gunnery Sergeant Murphy, sir!' A lanky marine threw a parade ground salute, gave Campbell that speciality bellow of theirs. 'Commanding here till hand-over at sixteen-hundred hours! You and your men are very welcome to this US Marine Corps base, sir!'

'Expect we are,' muttered Whitey. 'Now they get to leave this midden.'

Apart from the Marines' neat rows of equipment, plywood shacks and canvas awnings, the timeworn stronghold was little more than a stonework shell around a clutch of chipped sandstone blocks and crumbled heaps of mudbrick. But Campbell wasn't put off.

'Remarkable masonry for the period.' He gazed attentively around.

'Just some old fort, Lieutenant,' Murphy shrugged. 'Country's full of this stuff.'

'It is famous.' Khalid was offended. 'A most famous fortress, more than one thousand years old. A classic example of our early military architecture.'

'Well,' Murphy shrugged again, 'Iraqi military's all bomb damage now.'

A scramble up a ramp of pounded rubble brought us to a long steel platform anchored against the wall and sporting at one end a pair of heavy field bins on a tripod. Ollie nodded appreciatively, went straight over and focused them on that single worked field we had passed.

'What's the story with the village?' Campbell frowned at the shattered buildings, their derelict fields and dying palm trees.

'Something happened, but who knows,' Murphy said evenly.

'What's the story on the old Abdul over there?' Ollie raised his head from the bins. 'He's working soil that's been tilled. Not a weed in sight.'

'That old guy? He's harmless, maybe a bit strange.' Murphy shrugged. 'We've seen him going over that ground again and again. The only damn thing moving around here, most days. Maybe it's how they do their agriculture, who knows.'

'And maybe it's cover – maybe he's dicking us.'

'Dicking us?' Incredulous, Murphy turned to look, hand shading his eyes. 'What the hell? He's waving his dick at us?'

We tried not to snigger like schoolboys as for the second time that day Ollie struggled with the instant exasperation our entire platoon knew would be burning holes in his self-control.

'Observing and noting!' he snapped. 'Maybe that's what the old bastard's up to.'

'There's nothing happening here, Sergeant. Not till now. Pity I'm going to miss it.'

'You're welcome to stay for the party,' Campbell suggested drily.

'Orders, Lieutenant. You guys are the anvil – we're off to join the hammer.'

Murphy narrowed his eyes at the polished blue sky.

'Hear it? That's the lift coming.'

The Chinook's downdraft whipped up a cloud to redden the sun and deepen our fine coating of dust; the Yanks picked up their kit and filed on board.

'Good luck, guys, take care of the ville till we get back,' Murphy shouldered his pack, lifted his M16 and, as if in afterthought, turned and inquired solicitously, 'Oh, yeah – how you all settling down at Dogwood? Enjoying the fine facilities and accommodations provided by the US of A?'

'We'll be looking for a refund,' Skinner advised, poker-faced, and Murphy laughed.

'You've left some very nice stuff here.'

The Dog looked around thoughtfully.

Murphy laughed again, if less whole-heartedly, and then the Chinook thudded into the air, taking him and his men to where the fighting burned south from Falluja.

We had some scran and a brew – great to have a real cookhouse again; Ollie counting off working-parties to get us settled in – heavy weapons, communications and so on, halting when he came to our little group,

planting meaty hands on hips and surveying us with deep disapproval.

'I need a team to go take a look at that old Abdul – I've got to stay here,' Ollie flicked an unenthusiastic glance towards our new Rupert. 'Prefer to see you slackers sweat, but – Skinner, your little deals with the ragheads must have told you what they're like – you interrogate; Whitey, I'm not having you bimbling and moaning around here – radio; Dog – you watch their backs.'

My turn. Ollie turned on me that unnerving stare which suggested he knew everything about you, particularly the bits you hoped he did not.

'And sprog Robertson, maybe for once this little bunch will have something better to teach you than evading fatigues and getting into trouble.'

We collected Khalid and went back into the desolate village. No breath of wind to rustle dead foliage, tap a broken window-frame or clear that smell of rot, no sound but our voices and the dusty tramp of our boots. Again, it brought me the cold touch of apprehension.

'Won't be doing business here,' Skinner was stoic. 'No making a dinar, let alone a buck.'

'Or a girl,' Whitey said mournfully. 'And I need it bad. Don't laugh, it's a health thing, practically medical. Khalid, old pal, where's the nearest women?'

'Thirty klicks away with their husbands and their husbands' very sharp knives,' Khalid advised soberly. 'Any monkey business, they cut your throat. Eventually.'

'Sounds a bit like Tollcross,' the Dog reflected fondly. 'I think I might stay here after the war. Should fit in just wonderful.'

The old man wore a grey *dishdashah*, its flowing hem crusted with earth, a soiled white *ghutrah* lying untied over his head like a shawl. His feet were bare, toes spread, nails curved and yellowed. He neither lifted his head nor unbent his back from working the soil with a mattock, the blade cutting into a tilth already fine as breadcrumb, each blow raising a burst of pink-brown powder. A troop of scraggy crows patiently followed his progress, picking hopefully at the upturned ground, pausing to turn wary black eyes on us.

Khalid spoke and got no response. Tried again, then tugged at the *dishdasha* sleeve but the old man simply kept his eyes on the ground and shrugged his hand away.

'What to do?' Khalid was baffled, but not Skinner.

He stepped forward, caught the mattock as it rose and slowly the old man, as if waking from a dream, blinked, shook his head and gazed uncertainly at

him, as if not absolutely sure Skinner was real rather than phantom.

'*Salaam aleikum*,' said Skinner, with a respectful bob of the head.

'*Wa aleikum salaam*,' the old man slowly straightened with a wince, tugged at his untidy grey beard, mistrustfully took in our uniforms and weapons.

'Ask him if he'd like a fag,' said the Dog to Khalid, and brought out a packet.

The old man's face brightened, eyes fixing on the offered cigarette, placed it between burnt-brown lips and opened his hand.

'He has nothing to light it with.'

The Dog used his much-prized Zippo, bartered by a thirsty Yank in exchange for a bottle of Glenmorangie, and the old man eagerly sucked at the tobacco smoke, gave us a fleeting smile. Skinner began the questions.

'What's he doing here?'

'Waiting for his son to return.'

'Why's he working this field when it's already tilled?'

'He prepares it for winter wheat, keeps it ready for his son bringing the seed.'

'What happened here? How was the village destroyed?'

'Engine sounds in the night. Fire and explosions. Death.'

'Who… who did this – them? Some sort of punishment? Or… us?'

The old man looked towards the broken village, bowed his head reverently.

'Allah knows who did this.' Khalid also bowed his head. 'He will judge.'

'The old guy's clean,' the Dog announced decisively. 'He's no insurgent, just another poor workin' civvy with his life fucked-up.'

'Not all fucked-up – his son's coming home,' I put in. 'Khalid, ask him where his boy is now, when he'll be back.'

'Kuwait.' Khalid was slow in giving the answer. 'Serving in the army, the Iraqi army. His division garrisons Kuwait.'

We looked at each other.

'You've misheard,' Skinner said finally. 'That was ten years ago. The first time.'

'I have not misheard,' Khalid was offended once more. 'This is what he told me.'

'Ask him again.'

Same question, same response. Skinner stared expressionless; the Dog

grimaced; Whitey shook his head and I watched the old man, saw now in his abstracted gaze the distance retreated from unbearable truth.

'I don't know how… better tell him his boy's not coming home,' Skinner said, and Khalid lifted his chin in refusal.

'I will not tell him. This is all he has.'

'Here,' the Dog handed over the rest of his fags.

We stood silent as the old man give a broken-toothed grin of delight, and then his *ghutrah* shivered in a slight burst of air; he looked around, cupped his hand against his ear.

'*Sharqi*,' he said quietly and pointed where the valley rose into the desert.

'Sudden wind,' Khalid pursed his mouth. 'Very strong – can bring sandstorm.'

Above the valley's lip the sun began to redden once more; the old man drew his *ghutrah* down over mouth and nose. Wind pulsed around us, began to mutter angrily, the sun's blood colour slowly leaching to ochre, sky dimming to yellow twilight; the crows cawed and flew off into a dense copse of palms.

'Bad one,' Khalid raised his voice as the wind groaned louder. 'We should go.'

The radio on Whitey's back crackled our callsign, he turned away to listen, quickly handed the headset to Skinner.

'Ollie, with orders.'

We watched Skinner as he held the headset to his ear, saw him stare along the track leading to the growing sandstorm, the distant fighting.

'I understand,' he said finally. 'Get the boys here soon as you can.'

He handed back to Whitey, looked again at the glowering wall of desert tsunami curling into the valley, its first thin waves already in our breath.

'Six, maybe eight vehicles coming this way, using that sand cloud as cover. Probable enemy. The track'll bring them to us. We block the way till the APCs get down here – maybe ten minutes.'

'We should have goggles for this,' Whitey protested as we doubled across soft earth, murky air thickening in our throats.

'We should have a lot of things,' the Dog coughed and spat dust-stained spittle.

We took the water-bottles, soaked *shemaghs* and swathed them around

our faces to resemble some bunch of better-equipped bandits. The old man was suddenly running and limping towards the ruins, clutching his mattock, shouting anxiously.

'He can hear engines in the dark, just like before,' Khalid told us nervously. 'They're coming, they're coming now.'

A discordant grumbling crowded in the wind as that faint ghost of a sun slipped away, cloud swallowing light, fierce sand whipping, our eyes prickling, watering, barely managing a glimpse of blurred headlights cresting the valley slope and working slowly down towards us. Skinner called to Khalid through his muffling *shemagh*, the drumming of wind and closing engines.

'You'd better take cover.'

'That would not be manly,' Khalid's voice faltered briefly. 'And, and perhaps they are only refugees, not Saddamists escaping.'

'If it kicks off, get in that ditch, fast.'

Skinner faced down the storm-dark track, began waving his arm in the signal to stop.

'Here we go!' I suddenly needed the sound of my voice, the reassurance of others'.

No one answered.

We leaned into the wind, gripped our SA80s tight, slipped off safeties, squinted through the sights into blindly driving dust, those nearing headlights, the uncertain shapes beyond.

My hands were shaking… *my hands were shaking.*

Dikra Ridha

One Hour of Light

*On 28 March each year, households and businesses are invited to turn
off their lights for one hour in the evening to save energy and reduce
carbon emissions.*

Dear Auntie, today I turned off the electricity
for Earth Hour and thought of you in Baghdad.
You do that all the time, live with the lights off.

Though, it was a little difficult to find the right
tea bag and cut the cake in the dark, using a torch.
What did you do with your hour of light?

I heard it is often at four a.m. or some silly hour;
you'd be too sleepy to watch the news or a black & white film.
Your hour On is not well timed to switch the heating on,

listen to old time songs, or just sit under the light
shade and stare into space. This routine
killed your fridge-freezer. In my hour Off

I silenced the radio and enjoyed peace and quiet, ignored
the day's chores and snuggled with a hot water bottle.
You spend all day in your coat waiting for the lights
and I turn them off when I want.

Waking up to a Beautiful World

The children begin to scribble, describe
a weight they cannot grasp. World, they see

the loss on their mothers' faces. Fathers are gone.
The sun hides behind Super Hornets speeding

across the sky showering them in black
– the sound cuts through their chests. Teaching

them patience, how to find answers, and showing
them a future in holes in the ground. And the oil

burns. But on the boys' shoulders latch bodies
of old generations, nude, their bones tremble

to the babel of bombs. And hand in hand
in public graves skeletons shed tears:

they make wells for the thirst of refugees:
the black liquid attracts flies.

The Man who Stood up for Himself

The telephone ringing buzzes around the dead man's
ears. His wife's calling from Damascus. He stayed
to protect her father's house.

The ringing beats on the walls and floats
back into his body – it echoes between the flies –
like a crying;
his children praying into the mouthpiece:
please pick up the phone. Say you didn't
hear it for the beatings outside;
you missed it for the gunshots in the street.

In the waving heat, the telephone stops.
And the ringing
moves to the neighbours' house.
They pick up
and apologise for the words they're about to say:
we heard the door being smashed. We knew
who they were by the style of beating. We heard
punches, kicks, breaking and screaming.

Swearing.
Eight gunshots and chatter.
Then cigarette smoke rose over the garden wall.

Gerda Stevenson

Ballad of the Sadr Carpenter – Iraq, 2007

Once I made tables, chairs and beds,
but now it's coffins by the mile,
and wardrobes have another life –
barely emptied before they're filled –
far fewer married now than killed.

Once we had only two great rivers,
now a third: the Crimson Ditch,
where stray dogs lick the flooded banks,
the sweet-sour spate that sticks to our feet
in bone-dry rubble and dust-blown heat.

Once we had libraries and schools;
now scorpions swarm the cracked walls,
where blank-eyed orphans chant their lesson,
chalked on the board like a blessing:

the English words
for father, mother,
sister, brother,
family,
family,
family.

Photographs of Iraq
by Anmar Al-Gaboury

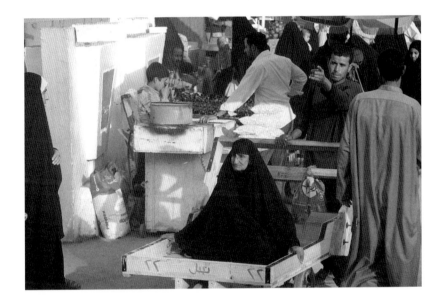

Old Lady in Wagon

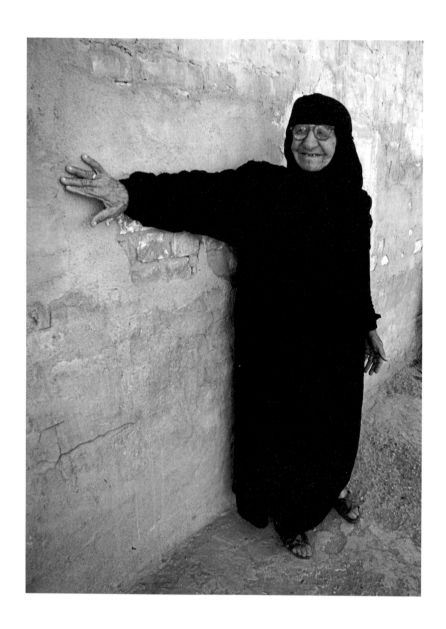

Street Boss

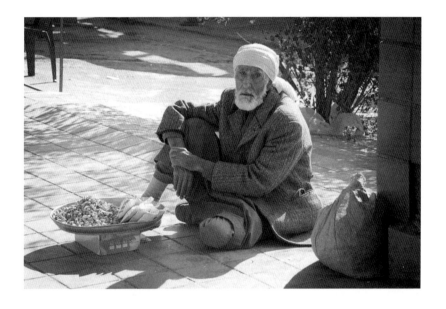

88-year-old Nutseller

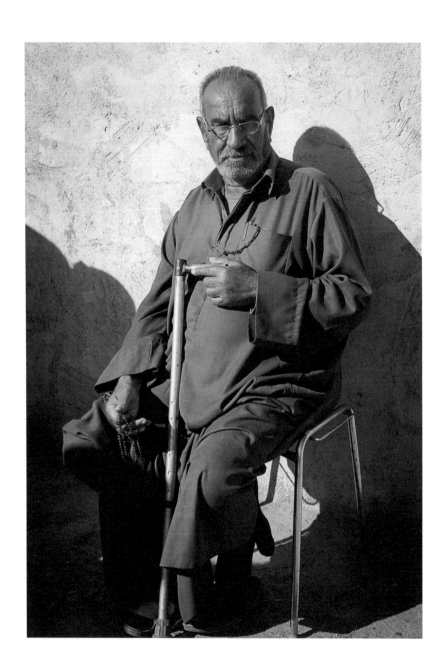

Killing Time

Adnan, 49 Years

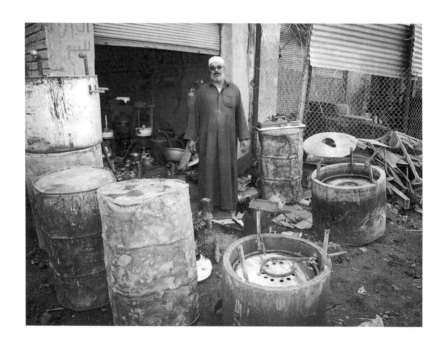

The Heating Man

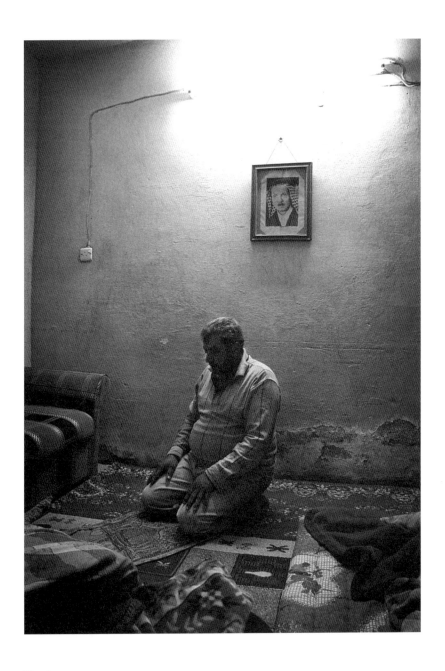

Praying

Love

Lynsey Calderwood

Space

Wully McCoy wis greetin the day. His cousin's girlfriend took an ecstasy up the dancin the other night an she went an died. Ah've never seen Wully greetin before. We wur in Home Ec makin this mad korma curry thing when Sammy Campbell shoutet, Heh who wants tae make a cosmic yoghurt, an then Wully jist pure burst intae tears.

It wis in aw the papers. Thir tryin tae make oot that it wis the first time she'd taen it but it wisnae. That time me an Charlene went tae the party in Wully McCoy's hoose his cousin John an her an aw thir pals wur pure spaced oot thir nut on it. They kept comin up tae us an giein us cuddles an sayin,

You're lovely, an wan ae them jist pure randomly tried tae get aff wi Chris Rice.Thir talkin aboot daein a drugs awareness thing in school. Wully says he's no daein it. Oor Drama teacher Miss Spence who's a pure mad hippy that wears aw thi weird tie died clothes – an evrubdy says probly smokes the wacky baccy hersel – she wis lik that, I understand your grief William, she said, But ah think it would be really good fur you to take part. Wully wis lik that tae her, Ah'll gie you fuckin grief ya fuckin space cadet, he said, an then he flung a chair at her.

Ah never really knew Wully's cousin's girlfriend. She wis in fourth year at oor school an she ast me fur a light wan time ah wis roon the smokers' corner

wi Charlene, but apart fae that she didnae really talk tae me. Her name wis Lesley Ann Bain but evrubdy cawd her Lesbian even though she wisnae wan. She wis quite a scare y lookin lassie. Ah don't understaun how John went oot wi her cos he's quite a nice lookin guy (even if he is a bit ae an idiot at times), an she wis a horror. She musta been aboot twelve or thirteen stone an she wis only aboot five foot tall an that time ah met her she'd on this wee crop top that wis aboot two sizes too small an it jist did nothin fur her.

Wan ae the papers ah read said she got straight A's fur aw her prelims she took at Christmas. Ah thought she'd of been in aw the dunce classes. Wully's cousin John's a right rogue, he's eighteen an he disnae work an aw he dis aw day is sits at home an smokes; yi jist canny imagine him gaun wi sumdy brainy. It said in the paper that Lesley Ann wantet tae go tae uni tae become a child psychologist when she left school.

It wis Lesley Ann's funeral the day. We'd this big assembly durin third an fourth period for the whole school. Thir wis hardly anybody there though cos maist ae fourth, fifth an sixth year hud went tae see her gettin buried.

We got made watch a video aboot this lassie that took drugs cos aw her pals wur daein it, an she thought she wis pure brilliant, an then at the end she's lyin in a hospital bed wi tubes stuck up her nose, an then this mirror image ae hersel comes in an starts talkin tae her an tellin her wit an eejit she wis fur takin the stuff in the first place. A lot a folk wur greetin durin the video (ah wisnae but ah nearly did); Sammy Campbell got flung oot fur sniggerin an wis made tae staun ootside in the corridor.

Wully McCoy come in jist as the thing wis finishin an sat right doon the front next tae Miss Spence. He looked dead different fae normal cos he hud his hair aw pure gelled flat instead ae spikes an he'd on a black suit instead ae his bright orange Tregijo jumper that he normally wears; ah caught his eye at wan point when he first come in but wisnae sure whether tae smile at him or what, but he jist looked right through me anyway.

We aw got tolt tae shut wur eyes an then we hud a minutes silence fur Lesley Ann; ah tried no tae look at Wully again after that because ah felt pure awkward, but it wis quite hard especially when oor heidy startet talkin aboot how Lesley Ann would be well missed, an then Charlene an Laura Kyle wur pure whisperin an starin right at Wully as if he'd jist grew horns. Ah half expectet him tae turn roon an say, Heh d'yi want yir eyes back, or somethin,

cos he's usually always got a sarky comment, but he never he jist sat there starin intae space.

The canteen wis deid at lunch time. A lot a folk went home after the assembly. Wully McCoy wis there though; He wis sittin at a table on his own lik a zombie an naebdy even went near him cos ah don't think anybody knew wit tae say. Charlene went up jist before the bell though an ast if he'd tap her a fag an ah coulda pure kilt her cos it wis obvious she wis jist daein it tae be nosey tae see if he'd say anythin tae her aboot Lesley Ann. Ah said, Charlene have yi never heard ae folk needin thir ain space; she jist looked at me as if ah wis stupit or somethin an then finally she said, You fancy him daeint yi. Ah said, Wit. She said, Yi fancy Wully McCoy an don't deny it, she said, Yir jist pure jealous ae mine an Wully's relationship. Ah wis pure bealin when she said that; ah said, Wit relationship's that Charlene, and she said, Wouldn't you like tae know, an then she walked away wi a big smirk on her face.

We got made dae this workshop thing in Drama this afternoon. We wur aw separatet intae groups ae four an five (it wis me, Yvonne Brookmyre, Sammy Campbell, an Bryan Allan) an the first thing we hud tae dae wis brain storm aw the names ae the drugs we'd ever heard ae. At first it wis aw the usual wans lik ecstasy an heroin but then Sammy startet sayin things lik cat in the hat an double o sevens an care bears (which accordin tae him are aw the same thing). Mind the time when we wur in primary seven, he said tae Bryan, An ma big sister went an gied us blues fur a laugh. Aw man don't even talk tae me aboot that, said Bryan. Ah wis pure surprised cos ah always thought Bryan wis quiet an sensible an stuff an it's jist pure unimagineable that him an Sammy Campbell would ever've been pals. Aye, said Sammy, He wis pure spongoed pure bouncin aff parked cars walkin alang the road an stuff. Oor group hud millions mair drugs names thin aw the other groups pit thegether cos ae Sammy, an Miss Spence went an wrote them aw up on the flip chart.

Is that the best yi can come up wi, shoutet Wully McCoy when aw the groups hud finished readin theirs back. Everybody went pure quiet cos this wis the first time he'd spoke since the chair flingin incident. Pit yir haun up, he says, If anybody in here's ever took a drug. Only him an Sammy Campbell an Miss Spence pit thir hauns up. Aye right, said baith him an Sammy at the same time. Wit aboot tea or coffee that's a drug, said Wully, Why don't

yi write them doon. Miss Spence did. Then he said, An wit aboot cigarettes they're a drug. Aye, shoutet Bunsen, Nicotine's a drug. Miss Spence wrote that doon anaw. Pit your hand up if you've ever tried smokin, said Miss Spence, tryin tae get in on the act. Wully, Sammy an ah couple ae other folk pit thir hauns up. Wit aboot you Charlene, said Wully, Want me tae smoke that fag fur yi that ah gied yi at lunch time. Charlene took a pure beamer. An wit aboot you Kirsty, he said, Ah don't see a halo floatin above your heid. Ah've never smoked an ah've never drank an ah don't like tea or coffee, ah said. Did you no have Strepsils in yir bag wan day. Aye but that wis fur a sore throat. Still a drug, said Wully. YAS, shoutet Sammy Campbell, Kirsty the junkie. Shut up, ah said. You're a pure raver Kirsty by the way, he said, an then he startet shoutin, GO THE MAD STREPSILS, and, AH'LL BUY THEM AFF YI.

We split intae wur groups again an each group got given information sheets aboot a different drug. Oors wis amyl nitrate an it gets cawd poppers an it's meant tae be fur folk lik ma gran that've got angina. Wit yi hud tae aw dae wis spend fifteen minutes readin up on whatever drug yir group hud an then try an sell it tae the rest ae the class by tellin them aw the good effects it can have on yi. Wully McCoy joint oor group an we wur that convincin that nearly everybody in the class pit thir haun up tae buy poppers (Charlene pit her haun up for every single drug though) but they aw changed thir mind again when we read oot the bad effects.

When ah got in fae school ma ma an da wur talkin aboot Lesley Ann. Ma ma said, Widdyi make ae that wee lassie fae Renfrew that died takin they drugs. Aye ah know, said ma da, Fifteen yir auld an she's a junkie. She's no a junkie, ah said. Well wit is she then. She isnae a junkie cos she didnae inject hersel. Still took drugs, said ma da, Still a junkie. Right whatever, ah jist said. It pure dis ma heid in when he says things lik that as if he pure knows everythin. Should fuckin hing aw the wans that sell it, said ma da, Or better still feed them thir ain shite an see how they like it. Aye bit naebdy forced her tae take it, said ma ma. Aye true, said ma da, But wit's the parents thinkin lettin a wee lassie ae that age go tae a night club anyway. It says here, said ma ma, That her mother blames hersel cos she used tae be an addict an noo she wants tae become a drugs counsellor. Bliddy drugs counsellor, said ma da, Is that before or after she comes aff the methadone program. Ah wantet tae

tell them baith tae shut up, tae say that drugs are everywhere an maist folk at school've took them. But then ma ma said, Anyway they got him, she said, It wis the boyfriend that dealt her it.

Wully McCoy hasnae been at school aw week. It said in wan ae the papers that his cousin John's been charged in connection wi Lesley Ann's death. Ma da said, Serves him right. Ma ma said, Aye well if yi dabble in that sort ae stuff then hell slap it intae yi. Ah still don't know wit tae think though. Ah jist keep thinkin aboot Wully McCoy an wit he said durin the drugs workshop an how less than two months ago we wur aw at that party in his hoose an Lesley Ann wis alive.

Wully McCoy's aunt Linda wis wi Lesley Ann when she died. She did this article fur a women's magazine talkin aboot how they'd baith took it that night. Apparently yir meant tae drink loadsa water when yi take ecstasy cos yir up dancin yi don't want tae end up dehydratet; wit happent though wis Lesley Ann drank too much an it endet up floodin her brain. Thir wis a picture in the magazine showin yi her linked up tae the life support machine an her face is aw swelt up lik a balloon.

Ah widnae wish that death on anybody, no even Sammy Campbell.

Sammy went an bought a bag ae speed aff this guy in fourth year the day an he wis sittin in French actin pure hyper lik he'd jist come aff another planet. Turnt oot though that it wis a total wind up an the guy hud gied him a bag ae sugar that'd been knocked oota Home Ec.

Gary Allen

Alone in a dream

The day the first coffins of the hunger strikers
were being carried through Belfast
I lay on the narrow bed of my prison cell
reading Conrad
the heavy steel door wedged open
so I could hear if Hetty
was coming down from the courts:
if I dream
I can see the traffic crossing the Rhine
my mother stockpiling tins and potted meats
in the pantry
my father greasing and hiding
the Luger he brought back from Germany.
Kurtz is inside –
the incarcerated have one name
scratched into the walls
the diagrams of cunts and erections
are universal
without desire, as if we really

have nothing to say anymore
like all the righteous, solemn faces
under banners and placards
my lover sad in Brussels
my lover polishing
the marble floor in the foyer
and so the long procession
along streets familiar, yet meaningless
to plots without comfort
portakabins, security frisking, name giving
the suspicion of every visit
the suspension of the rooms we left that morning.

The State

They are pulling the State down
steel ribs suspended in a piece of blue sky

once plush red seats thick with mildew
the floors pitted with water
the lone toilet sign – Gents

the wrecking-ball punching holes in the murals
of once famous American film stars.

The pissed-off usherettes with their pencil torches
tray of chocolates, cigarettes

are gone

the teenagers drunk on cider are gone
the lovers are gone
the National Anthem is gone

the boys who booed the newsreels
and went off to a real war, are gone

some never came back

the glass jam jars to the Saturday matinees
the serial Westerns
no longer stacked in the foyer.

The iron machinery clunks to a stop
the line of people waiting at the temporary halt
for the Glenravel bus

aren't dancing in the rain.

We have a grand peace now, they tell us
real and lasting as a hollow forest

the factories are closing again
the building-sites empty
the Poles are gone

still, we have a brand-new carriageway
shooting straight as Robin Hood's arrow.

Charles Bennett

A Year Underwater

SUMMER

I once lay down in a pond. I stretched
along the bend of its dried-up centre

and said to myself: now you're drowning
in air. I felt the damp pond-weed

stipple my skin, as I drowsed my spine
on a small, moist hammock. I slept

and dreamt of rain. And then I woke
and found I was filled to the brim.

AUTUMN

I once dropped a book in a pond
and saw the soaking read its pages clean.

If I swallowed a sip I tasted
the alphabet's liquorice – if I spilt

a drop I heard the murmur of verbs.
At nightfall, furls of paper rose

to the surface, and wrote in the shape
of snow-fish spoken by water.

WINTER

I once took seven steps across a pond
and felt the pang of ice

strike in seven fractures. I stood
on the other side of a small miracle,

knowing the craze of my tread
would be absorbed by melting

and made invisible. Sometimes I think
my footsteps are still in the water.

SPRING

I once held a pane of pond-ice
up to my face, a loose leaf of water

clenched by winter. It stung my grasp
with a flinch of frozen breath. It spoke

a word that bit my fingers black. It was only
when I took it to the sea and kept it under

it started to shimmer and blur. By and by
what I held in my hands was perfectly clear.

Scarecrow

Sapling in a coat, you bear
no fruit except these drips of rain.

Little crucifixion in the field,
under your gloves the finger-buds

throb and ache. For you the hailstones
come up snowdrops in spring,

for you the hares are dancing beneath the stars.
In summer your bedraggled hat

is a dried-up riverbed, in winter the wind
blows through you, singing of ice.

Would you drop your arms if you could,
or are you the stem of an angel

blessing the stubble? Stretching to reach
the hedges and touch their green,

you wrench your welcome open.
I walk up the lane tonight

and see you lifted on tiptoe,
like someone taking a breath

before they make a swallow-dive
into the earth.

Reviews

Muriel Spark: The Biography
Martin Stannard. Weidenfeld & Nicolson. ISBN 9780297815921. £25.00

If the many stories behind the delays and postponements of the authorised biography – which Spark herself commissioned in 1992 – are to be believed, then the appearance of this book is all the more welcome and all the more remarkable. It had been reported that, as the Dame read more of Martin Stannard's manuscript, she became correspondingly more unhappy with her anointed biographer. According to A.S. Byatt, in a *Daily Telegraph* article in 2007, '[Spark] was very upset by the book and had to spend a lot of time going through it, line by line, to try to make it a little bit fairer... I think she rather wished she had not got involved with the project in the first place.'

Whatever the reasons for the delays, and despite Spark's intense scrutiny of the manuscript, and the long negotiations that continued with the estate after her death in 2006, Stannard has, nevertheless, produced a rather fine biography which interweaves discussion and analysis of the work with his presentation of the life. His approach is right and fitting, since all Spark's own writing was nothing if not autobiographical.

From the opening paragraph of his Introduction, Stannard acknowledges the paradoxes surrounding his complicated and complex subject. By the time he was invited to write her biography, Spark was already 'something of a monument in the literary establishment', and, following Graham Greene's death in 1991, was regarded as 'the greatest living British writer', yet 'she was also an exile and an enigma'. Spark's literary reputation was huge, yet it was also 'that of a recluse: a mysterious figure whose biographical file was anorexic'. And while Stannard writes that his subject was happy to allow people to consider her work as public property, her life, 'she insisted, was *her* life, and she was determined to control it.' For example, by the time she was 25, she had exited Edinburgh for Rhodesia, had married there, had given birth to a son the following year, by which time her marriage had broken down, and by 1943 was divorced, and so it is not surprising that Spark should have felt that she was not in charge of her life. Given the many difficult personal circumstances in which she found herself at various times, it was always a struggle for Spark to take and then maintain control. And it is her characteristic determination, even ruthlessness, that Stannard emphasises time and time again in his account of Spark's pursuit of her vocation as a

writer – in her dealings with her family, with her lovers, with her publishers, and with her friends. These revelations leave the reader with the feeling that it must have been very hard work being Muriel Spark.

Running to almost 550 pages, Stannard's biography certainly does not short-change Spark, nor does it give her short shrift. He writes that, when Spark appointed him as her biographer, he 'fell into her life, but never became part of it'. Indeed, he says, 'why this intensely private person should have invited someone to write her biography remains mysterious'. A sympathetic biographer, Stannard is no hagiographer. When he shows Spark taking vicious swipes at her family, mostly at her mother and her son, and at those old friends she had grown too grand to know, he does not seek to soften the harsh light that she presents herself in. On the question of what Stannard calls the 'racial origins dispute' between Spark and her son Robin, while he certainly underplays the young Muriel's involvement in the life of the Edinburgh Jewish community (in which she did, after all, spend her first nineteen years), and omits to mention her brother Philip's bar mitzvah in 1925, he does reveal some new information, which leads him to conclude that it is 'possible that Adelaide [Spark's maternal grandmother] *was* Jewish after all'. This is of real interest, and if true, where does it leave Muriel, given her infallible pronouncements on the subject?

On the human interest side, we learn that Spark was a sucker for aristocrats – real and fake – and she liked to surround herself with more gay men than you could shake a stick at. The firing-off of 'Exocet' letters to those who had got in her way, and her frequent threats to sue those who had crossed her, were all as much part of her routine as were her 'shampoos and sets'. And because for Spark, 'writing was not only a vocation, it was her business', we do get to learn much about the place of money in her life, and the making of it, her argy-bargies with publishers and how she would always push for higher advances, the financial demands reportedly placed on her by her family, and her eventual purchasing of various properties and the racehorse; but disappointingly there is little or no mention of any of the actual sums involved. And though very few need to be convinced about the importance of Spark's massive literary legacy, we are none the wiser about the extent of her estate. Did she leave a fortune, as was reported, of three million pounds, or just thirty bob? It is a little unsporting of Stannard to deprive us of this information.

This compelling and shrewdly written biography does tell us a great deal about what went to the makings of Muriel Sarah Camberg, or Spark,

assuredly one of the most important and influential writers in English of the post-war period. Not that it tells quite all. And that Stannard does not avoid presenting his subject as imperious and exhausting is one of the honesties of his book. In his summing up he writes, 'this was a woman who could go white with rage… was a murderer of illusions, had a vision of hell on Earth and had to live with it. This could lead her to overstate the villainy of those she saw as betraying her. Sometimes she was unable to believe that she had ever said or done things that contradicted what she had wanted to appear in the authorised version of her life.' Proof positive, were it needed, that the biographer is no hagiographer.

There remains one slightly puzzling matter, which has all the hallmarks of a scenario from one of Spark's later novels, and this is her burial. Counter to her apparent request for the simplest of funerals, her parish priest, 'believing that Muriel's body should be preserved for future generations', arranged for her to be buried instead 'in a solid, zinc-lined coffin not directly in the earth, but in a concrete niche'. Such provision is usually reserved for those in with a chance for promotion to the official catalogue of saints, for which incidentally Muriel's beloved Henry, Cardinal Newman, is in the running – though he, of course, is a bit further up the list. If this is to be taken as Spark's last joke, then it must surely rank amongst her wittiest.

Michael Lister

The Bloodaxe Book of Contemporary Indian Poetry
Ed. Jeet Thayil. ISBN 9781852248017. £12.00

Not all the seventy-three poets included in this anthology are still alive. Some write in other languages as well as English. Many live in the West. In the middle of the book is an essay by Bruce King on Nissim Ezekiel, Dom Moraes and Arun Kolatkar, all of whom died in 2004. Every entry comprises several poems and is preceded by an autobiographical note of some detail. Thayil's own Introduction sets out his aim to represent Modernism in Indian poetry in English as dating approximately from the time of Independence, stating, 'these writers were in a hurry to overthrow the conventions of the Indian bourgeois as well as those of their once colonial masters'. He suggests that poets writing in indigenous Indian languages were quicker to be open to American or European literature and less in thrall to English literature.

The problem of writing in English in India is the sense of not belonging anywhere particular (A.K. Ramanujan describes himself as 'the hyphen in Indian-American') and writing therefore for a small circle of others who do the same. It is clear, however, that not belonging anywhere can also give the freedom to be yourself anywhere, as many of these poets demonstrate. Melanie Silgardo writes of Mrs Patel 'laying her Avon catalogues on the counter' while her cousin in Gujarat 'knows the weather in Derby'. There is a sense of drive in many of the women poets, and perhaps of world-weariness in some of the male poets writing more, verbose poems to display their sophistication and erudition. Compare, for instance, Tishani Doshi in 'Homecoming'...

> I forgot how Madras loves noise –
> Loves neighbours and pregnant women
> And Gods and babies
>
> And Brahmins who rise
> Like fire hymns to sear the air
> With habitual earthquakes.

with Vijay Nambisan's equally evocative but more wordy 'Madras Central'

> The black train pulls in at the platform,
> Hissing into silence like hot steel in water.
> Tell the porters not to be so precipitate:
> It is good, after a desperate journey,
> To rest a moment with your perils upon you.

Jeet Thayil read at the Edinburgh International Book Festival at a Scottish Poetry Library event to celebrate the Jubilee of Independence in 1997. He took part with Sudeep Sen, who had been poet-in-residence at the Scottish Poetry Library in 1992–93, and who subsequently guest edited *Lines Review* 138 in 1996, as 'Twelve Modern Young Indian Poets'. Of those twelve, seven are included in this anthology yet Sudeep himself does not feature. Imtiaz Dharkar, a Bloodaxe poet, born in Glasgow, also read at the Book Festival event, as did Sudesh Mishra, who was on a fellowship at Stirling University. Vijay Nambusan was also a Stirling fellow and Eunice De Souza read at the opening party for the Scottish Poetry Library in January 1984. Sampurna Chattarji visited Scottish PEN from Bombay PEN in 2005. These are all in Thayil's anthology. I mention these links with Scotland, as they are easily overlooked and are of interest to the story of Scottish–Indian literary relations.

In Arvind Krishna Mehrotra's essay 'What is an Indian Poem?', there is a discussion about translations of the Italian poet, Giuseppe Gioachino Belli, who wrote in a Roman dialect. Mehrotra praises translations by Harold Norse in the mid '60s into an American idiom to correspond with Belli's Romanesco dialect. This is in connection with Arun Kolatkar writing in English, Marathi and Bombay Hindi patois. It is a pity that connections with Scotland and its minority languages have not been made, and in particular Robert Garioch's acclaimed translations of Belli sonnets into Scots.

Highlights for me, among a great many, in this volume are: Kolatkar's marvellous Pi-Dog poem, C.P. Surendran's witty poems such as 'Family Court', Sujata Bhatt's sensuous 'White Asparagus', Agha Shaid Ali's Kashmir evocations, Melanie Silgardo's poem from 'Beyond the Comfort Zone', Gopal Honnalgere's 'How to tame a new pair of chappals' (ie, open sandals) – 'don't leave them together/don't allow them to talk to each other/they may form a trade union', Arundhathi Subramaniam's 'To the Welsh Critic who doesn't find me identifiably Indian' – 'reading my Keats – or is it yours…'

One of the frustrations of the anthology is that the authors are neither in chronological nor in alphabetical order except in an index at the end. The order is more organic perhaps, but this makes it hard to find a guiding path through the wealth of words and varieties of kind of poem. Indian poets, 'seen as one body of work' wherever they are based, as is the declared intention of the editor, are clearly weaving their multi-cultural way through the English-speaking world with power and talent.

Tessa Ransford

Contemporary Iraqi Fiction: an Anthology
Ed. Shakir Mustafa. Syracuse University Press. ISBN: 0815609027. £21.50
Madinah: City Stories from the Middle East
Ed. Joumana Haddad. Comma Press. ISBN: 1905583206. £7.95

These two collections of short stories from the Middle East are markedly different in character. *Contemporary Iraqi Fiction: an Anthology* contains thirty-four stories by sixteen writers and succeeds in demonstrating that modern Iraqi fiction contains excellence across a range of styles. It appears that editor Shakir Mustafa has faced no shortage of quality writing to choose from in deciding which stories to include. Some of Iraq's most prominent writers feature (some of these already possess an international reputation) but Mustafa has taken the bold step of also including work by younger writers who, he says 'have been generally underrepresented in English translation.' That he succeeds in placing this work alongside stories by better established authors, without any faltering in the quality of the writing, is testimony to a strength and depth in Iraqi fiction that looks set to continue, and that would deserve to attract widespread attention.

The featured writers come from all the main cities and regions of Iraq. Some have an Arabic background, while others are at least partly Assyrian, Kurdish or Armenian, and there are several Jewish and Christian as well as Muslim writers. As could be expected, this variety is reflected in the mixture of writerly concerns, themes and styles that populate the volume. Also enriching the mix is the fact that nine of the authors have left Iraq and now live and write abroad (in the USA, Europe or Israel). Shakir Mustafa obviously feels that output from this group of writers is of special value, stating that: 'the Western experience seems to have enabled liberating and bold visions,' and indeed, where Western influences rub up against Iraqi émigré concerns is where this collection produces some of its most engaging results.

Samuel Shimon, born in Habbaniyya in 1956, lives in London. His story, 'The Street Vendor and the Movies', is set in predominantly Sunni western Iraq, and contains Christian as well as Muslim (Shia and Sunni) characters. It deals with a group of Iraqi youngsters who are obsessed with American cinema, and Shimon's style is direct and highly visual, drawing on different story-telling traditions to produce writing that feels unique and vital. While the main character's concerns are local, they also ring true and familiar to a reader from halfway round the world. This could be because Shimon captures the directness and joy of childhood, with the children largely ignoring the

religious, ethnic and social boundaries that their parents unthinkingly try to pass on to them.

Mustafa points out that, since the 1970s, writers exploring alternative approaches to social realism have added numerous strands to Iraqi fiction. One problem suffered with realism is that pushing the boundaries in terms of content has carried political risks (two writers here were imprisoned under Saddam Hussein's regime). The stories by Muhammad Khodayyir and Luftiyya al-Dulaimi, both internationally recognised writers, demonstrate a strong tendency towards formal experimentation, and are also visionary in character. Khodayyir re-imagines his home city of Basra with surreal touches (calling it *Basrayatha*) while al-Dulaimi's strong visions of death and destruction underline the fragility of civilisation. Their writing retains sufficient solidity, however, to sustain story-telling of remarkable beauty, in al-Dulaimi's case with a redemptive moment in 'Lighter than Angels'. Meanwhile, Mahdi Isa al-Saqr's story, 'Breaking Away', jumps between everyday reality and a magic-realist fantasy whose quality is reminiscent of fairy-tales. Even the stories that are most playful or fantastic, however, betray a strong attachment to lived experience. Al-Saqr's fantasy is not very far from the 'real' world after all, perhaps arising only out of the main character's sensitivity to beauty in everyday objects. Iraqi writers have also addressed problems in society through stories that boldly affirm women's experiences and critique the negative attitudes towards women that continue to dominate in Iraqi society. The stories by all five women writers and by Shmuel Moreh are good examples.

Madinah: City Stories from the Middle East contains ten stories set in cities from Istanbul in the west to Dubai and Baghdad in the east. The quality of the writing in this volume varies considerably from one story to the next, but those that stand out include Nedim Gürsel's 'The Award', set in Istanbul, which tells poignantly of a homecoming, and Yitzhak Laor's 'Meningitis', set in Tel Aviv, which insightfully realises an awkward father–son relationship. Hassan Blasim's story of a kidnapping in Baghdad, 'The Reality and the Record', is particularly strong. Even while the events are gripping and dramatic, the story is sombre, even stately, as the main character considers death face-on. Each story here has a different translator, which adds to the variety. By contrast, all stories in *Contemporary Iraqi Fiction: an Anthology* are translated by editor Shakir Mustafa, and since Mustafa's translating is excellent, this benefits his collection greatly, lending overall coherence to a book that introduces diverse voices in modern Iraqi fiction.

Alasdair Gillon

Memories of Eden.: A Journey Through Jewish Baghdad
Violette Shamash. Eds. M. and T. Rocca. Forum Books. ISBN 9780955709500.
£14.99
Baghdad, Yesterday: The Making of an Arab Jew
Sasson Somekh. Ibis Editions. ISBN 9659012586. $16.95

Sixty years ago, more than a third of the population of Baghdad was Jewish, with a history of over 2,000 years in Mesopotamia. When Violette Shamash (her married name) begins her story, in the early years of the last century, the Jewish community was at the heart of Baghdad's business and cultural life. Jews spoke the same language as their Muslim and Christian neighbours, and although religious observances differed, they broadly shared their way of life. Half a century on, almost nothing remained of that vibrant and integrated culture. Violette's family – her parents and six siblings with their spouses and children – were dispersed in three continents.

Memories of Eden (the Garden of Eden may have been located in the Tigris and Euphrates valleys) is a beautifully executed and richly textured account of a family and a community. The Ishayek family were well-to-do merchants with a fine house on the banks of the Tigris. Violette's finely observed documentation of life in Baghdad between the world wars is compelling, domestic in focus but embracing a much wider context, and reflecting, directly and indirectly, world events and the manipulations of European powers.

Sasson Somekh was 17 when he left Baghdad in 1951, ten years after Violette, her husband David and two infant daughters had hurriedly departed for India. He was alone – his family remained in Baghdad – and as a non-observant Middle Eastern Jew he knew no Hebrew and no Yiddish, a double disadvantage. Like Violette, he spoke Arabic, and also English (his father worked in a British-owned bank) and French (he went to a French school). He wrote poetry in Arabic, and hung out with Arab poets and intellectuals who encouraged him. He hints at the difficulties of adapting to life in Israel, alien territory, but his book is about Baghdad and his love of Arabic culture – he would become a founder of the Department of Arabic Language and Literature at Tel Aviv University.

The accounts of Violette and Sasson (the same name as Sassoon; the British Sassoons were related to Violette's family) inevitably intersect. The Tigris plays a leading role in both, the same places appear, the same names, the same ambience of Baghdad sights and sounds and smells, the same warm

response to environment and people. And the same events changed their lives for ever and destroyed the community that produced them. Although during World War I, Jews were suspected by the Turks of collaborating with the British, by the time Iraq was created in 1921 the Jewish community felt, as Sasson writes, 'secure and integrated, rooted in the country'. The British mandate, with a sympathetic King Faisal on the throne, seemed to bring security. In the 1930s that began to dissipate, and after independence and Faisal's death came, in Violette's words, 'the first breeze of anti-Semitic propaganda' blowing in from Nazi Germany. With the arrival in Iraq of the virulently anti-Jewish Grand Mufti of Jerusalem in the late 1930s and the seizure of power by Rashid Ali in 1941, life for Baghdad's Jews became increasingly difficult.

As the British struggled to maintain a hold on the Middle East, attacks on the Jewish community intensified, but when British troops advanced on Baghdad and camped on the opposite bank of the Tigris the tension began to ease. Baghdad surrendered, and an armistice was negotiated, though the British were ordered not to enter the city and Iraqi troops were not disarmed. It was the time of the Jewish festival of Shavuot or 'Iid el-Ziyaaghah, and Jewish families felt relaxed enough to carry on their celebrations as normal. But on 2 June 1941 there erupted two days of rioting, looting and murder, while the British were ordered not to intervene. The seven-year-old Sasson watched from a window as looters bore off their trophies from Jewish homes and businesses. Violette, married by this time and imminently expecting her second child, hid with her family in their darkened and barricaded house. Both families survived, thanks, in the Ishayeks' case, to the Muslim cook convincing the rioters that theirs was a Muslim household. There were many instances of Muslims risking their own safety to protect Jewish friends and neighbours.

It has been calculated that at least 130 Jews were killed during the *Farhud*, roughly translated as 'violent dispossession' or pogrom. The loss of life was greater than in Germany's *Kristallnacht* in November 1938. Yet, according to Sasson, after the war the Jewish community rallied. His teenage years were spent in 'a Baghdad bursting with activity' where the Jewish community 'had regained its full creative drive'. But anti-Semitism surfaced again with the creation of the State of Israel in 1948 and the wave of resentment against the British who were regarded as complicit in the dispossession of Palestinians. The trickle of departure that followed the *Farhud* became a mass exodus in 1950 and '51.

These books not only chronicle the life of a community, they portray a city that had a profound personal and cultural impact on both authors. Sasson Somekh's gentle, reflective reminiscences are full of insight born of deep appreciation of the cultural richness that drove his aspirations as a poet writing within an Arabic tradition. Woven through his account is a fascination with language echoed in Violette's writing: Jewish Arabic spoken at home, Muslim Arabic on the street; French and English; biblical and modern Hebrew. Violette's inclusion of a Judaeo–Arabic lexicon is itself a fascinating testament to integration. Language plays its part in her vividly recreated tapestry of family life and religious observance. Both writers illuminate the historical and political context, augmented in Violette's case by the very clear explication of the 'inside story' of the *Farhud*, provided by her son-in-law Tony Rocca. And, for those who want to know more, I can also recommend Marina Benjamin's *Last Days in Babylon*, which recounts her family's departure from Baghdad and her own risky visit there in 2004 to track down the remaining fragments of Jewish life.

Sasson dreams of returning to stroll along the banks of the Tigris, the river that has never ceased to run through his dreams. But these books are about loss, not just the demise of a once thriving community but of the ancient city and culture that nurtured it. They are also about the impact of power struggles originating in other continents and their continuing terrible legacy of greed and contempt for peoples and their past. The undercurrent of these stories is the destruction of human life and of the cultural and social rhythms that sustain it. The latest chapter in Iraq's story perpetuates the loss and the tragedy.

Jenni Calder

Ménage
Ewan Morrison. Jonathan Cape. ISBN 9780224084406. £12.99

It's amazing what a bit of French will do for you. 'Threesome,' sounds raunchy and vulgar, whereas *ménage à trois* has a beautifully chic ring. It conjures up elegant images from François Truffaut's classic film, *Jules et Jim*, or perhaps from the eighteenth-century real-life *ménage* of the beautiful Emma Hamilton, the brave Horatio Nelson and Emma's husband, name irrelevant. It is the sexual eccentricity of choice for people who like a bit of a home life in and amongst their dalliance. *Ménage à trois* literally translates as 'household of three'.

Ewan Morrison dispenses with any historical window-dressing or irrelevant elegance. Set during the last twenty years, his novel explores the twisted lives of three dirty young things, Owen, a freelance art critic, Dot Shears, a Young British Artist (YBA) and flamboyant, fucked-up Saul. Morrison's book opens with Owen's 'usual ritual' of masturbating whilst wearing pink panties, FedExed to him by CANDYGIRL, who charges for such services. You know that whenever a (usually male) author writes about 'panties' then you're in for plenty of genitalia. Just to make sure, Morrison adds: 'These were the limits of his deviances now,' the last word resonating ominously.

The extent of Owen's past 'deviances' become increasingly clear as the novel cuts back to the mid-90s backstory, when Dot, a fragile artist from an affluent, damaged home, rents a smelly and over-priced room in the men's flat. Owen sets about being a mildly decent bloke, whilst Saul makes his views of her current artwork clear: 'Bourgeois… reactionary… obsolete! You may as well delete them!' However, after much emotional turmoil, Dot ends up adopting Saul as a kind of muse and comes up with some of her best artwork, which takes the form of video installations that usually feature the three of them. Whether dressing up the men in women's clothes, or tying up Owen and slapping and kissing him, this is YBA stuff seemingly at the top of its game.

Meanwhile, whilst the three produce ever more promising artwork (with Dot as director), they are pulled into a *ménage à trois*. The fever of their evolving relationship(s) inspires them to even greater 'life as art' installations. The trio preserve their ménage by deception and pretence, fanning their lust to an almost ritualised level. Then it snaps, although the problem is not the ménage as such, but, funnily enough, a sudden moment of truth. In a

recent interview in *The Times*, Morrison has said, 'for a ménage to flourish, everything must remain unsaid, there must be secrets and deceptions, all conflicts must be kept alive, inflamed, eroticised. Flying in the face of our modern values, it is not self-expression but the constant suppression of truth that is empowering.' This can all be a bit perplexing, or in fact worrying, if you think about it too much, but Morrison is a dab hand at creating unconventional, solipsistic and above all, believable characters, firmly rooted in a scene. Morrison incorporates extracts from Owen's professional musings about the meaning of Dot's artwork, showing how it has stirred emotion and controversy on a grand scale. At the same time, the queer hollowness of the YBA scene is exposed – its vicious, boring, shocking inanities. Sometimes the satire can seem a bit forced and the name-dropping a bit prolific, but on the whole it rings true, possibly because Morrison writes from experience.

The novel, almost amazingly for one that makes such frequent use of the word 'cock,' has moments of real poignancy and possibility. Saul, the great muse, turns out to have borrowed most of his worldly wisdom from a trashy soft porn book and a dictionary of quotations. Dot, after her first explosive entrance onto the art scene, is only able to re-make what she's made before, because she can't seem to function as a lone artist. Owen, despite his lust/love for Dot, has a perennial problem with premature ejaculation – and power. In any *ménage à trois*, there is always going to be a struggle for balance and someone, like Owen, turns out, at least initially, to be the rather soggy filling in the relationship sandwich.

Morrison's book may make you feel 'ancient and suburban', to quote one literary critic, even if you're not ancient and suburban, but that doesn't mean that *Ménage* is solely aimed at priapic young men. It is a mark of Morrison's talent that the book's fast pace, intense characterisation and tight structure keep a reader turning the pages rather than girning at the more outrageous scenes. 'There is nothing less sexy than sex,' maintains Saul, which can't quite be taken as a mantra for the book, which is pleasantly racy in places. But it is a fair indication that *Ménage* was always going to be a bit more than chick lit (which also features a lot of anatomical references) for the intelligentsia. *Ménage* is a shrewd and complex book that tackles head-on the challenges and tragedies of this peculiar phenomenon.

Hannah Adcock

Reheated Cabbage
Irvine Welsh. Jonathan Cape. ISBN 9780224080552. £12.99

Re-reading the stories in *Reheated Cabbage* will be a nostalgic experience for some. Most of the book is made up of pieces that appeared in magazines and anthologies that are now out-of-print, and date from the time when Danny Boyle's film made Welsh a household name. In Welsh's Edinburgh everyone knows everyone else, and these stories are full of familiar faces. Some of the characters from his other books re-appear, while others are referred to in passing. You get the impression that Welsh has been writing about the same group of friends from the beginning, and that nostalgia has played a big part in his attachment to these tales of death, drugs and dance music. Welsh's cruelty, his desire to shock, is in evidence from the beginning. In 'A Fault on the Line', a woman loses her legs while crossing a railway line as her partner – the narrator – rushes to get home in time for the Edinburgh derby: 'As far as it went wi me it was aw her ain fuckin fault,' he tells us. 'The cunts at the hoaspital basically agreed wi ays n aw, no that they said sae much, bit ah could tell they did inside.' In 'Catholic Guilt (You Know You Love It)' the narrator assaults a gay man in London and is made to repeatedly rape his male acquaintances as a penance. In 'Elspeth's Boyfriend', Frank Begbie head-butts his sister's boyfriend after he hits him on the back to dislodge the Christmas dinner he's choking on.

Welsh's approach to violence, his fawning to football casuals, has always been caught between unconvincing social commentary and a vicarious pleasure in being in with the hard crowd. More than once we're told that his characters are violent because of abuse and maltreatment when they were young. But Welsh's heart doesn't seem to be in it. Rather than exploring the causes of violence, his explanations seem more like excuses, justifying not just the characters' behaviour but also the reader's voyeurism. That voyeurism is the other side of Welsh's nostalgia, and manifests itself in his fascination with the young team.

In 'The Rosewell Incident', Welsh's obsession with the lives of people much younger than him meets the flying saucer and little-green-men cliché of B-movie sci-fi. His aliens speak with an Edinburgh accent having learned 'Earth-language' from a Hibs supporter they previously abducted, and go on to try to establish a group of casuals as rulers of earth. On a better day, Welsh's 'mixing' genres – to borrow one of his embarrassing dance music metaphors – could be the basis of a much deadlier kind of comedy. But

Welsh, if he's trying, doesn't really pull it off here and you're left wondering whether what you're reading is pastiche, or just bad writing.

Some of his best work is still in the first person and his writing in Scots often works better than the sections in English, not because of 'authenticity' – his Scots prose is, if anything, more stylised than his English – but because he seems more disciplined, less adjective-happy. Welsh develops his characters through their voices. The more he writes from a character's point of view, the more detailed the psychological portrait he creates, if only through an effort to avoid repetition. In some of the shorter narratives in this book – like 'Kissing and Making Up' – he doesn't get a good enough go at it, leaving the characters no more than voices. Other stories are marred by unconvincing caricatures, particularly of women and middle-class characters like the pervert dentist in 'Victor Spoils'.

The novella 'I am Miami' is the only item not to have been published until now. It recounts how Lewis-born school teacher Albert Black meets up with former pupils Carl Ewart and Terence Lawson while they attend a DJ convention in Miami. Black is another familiar Scottish stereotype, a brutal dominie whose rigid Christianity drives him from his family and makes him an object of fear and ridicule in equal measure. Ewart – the DJ 'N-Sign' – is Welsh's lad o' pairts, the one who made it while the rest of the group either stayed at home, ended up in prison or died. Despite the predictable comparison between being high on ecstasy and religious epiphany and the embarrassing pun on 'old school', the encounter does produce an interesting revelation. At the end of this collection of b-sides and rarities, Welsh seems to move beyond the nostalgia that has been central to his writing since *Trainspotting*. 'Dance music is a young man's game', says Ewart. 'It's time I phased it out.' About time.

Niall O'Gallagher

Here, Bullet
Brian Turner. Bloodaxe Books. ISBN 9781852247997. £8.95
The War Works Hard
Dunya Mikhail. Carcanet. ISBN 185748698. £9.95

It would be reductive to call *Here, Bullet* a 'themed' collection of poetry, or even to give the impression that it is comprised of 'war poems' *per se*. While the poems here spring directly from Brian Turner's experiences as a soldier in Iraq, it is perhaps more apt to say that they deal with the occupation of soldiering: with that occupation's effects on a human being, and how one comes to accept the surreal landscape of war. Turner writes, in 'The Hurt Locker', 'Believe it when you see it./Believe it when a twelve-year-old/rolls a grenade into the room.' This image encapsulates his method: shocking in a way that is not gratuitous, unabashed by the emergence of profanity, or the complexities of morality.

The success of these poems is due entirely to their source: a poet gone to war. I say this to point out that Turner is a poet first, possessed of an awareness for poignant detail and the talent to render unbelievable images with words. His poems range from impassioned invocations such as 'Here, Bullet' and 'To Sand' – lyrical, image-laden, and visceral – to more pensive narratives that take a measure of the conflict's tolls. The best of these are 'Cole's Guitar', in which the war is a silent backdrop to the poet's thoughts of home, and 'Ferris Wheel', in which the full cost of war takes the foreground as the speaker watches a rescue party pull from a river more bodies than they were searching for. While looking inward, searching for reason or hope, Turner is always thinking outwardly as well, so that the poems become more inclusive than simple reportage.

Finally, Turner does what the nightly news, for all its analysis and traffic in images, seems unable to do, engaging the history of the region and its people. At one turn he reaches back to the roots of analytical geometry (in 'Alhazen of Basra'), and at another ('The Martyrs Brigade') he investigates the true longevity of the war and the rationale behind violent self-sacrifice. There are too many good poems in this book to name, packed with gut-wrenching details frankly delivered. They are the poems of this conflict that we have been lacking until now. Turner reminds us with *Here, Bullet* that Iraq is a place, inhabited only recently by foreign soldiers; populated much longer by a citizenry who carry with them the history, myth, and hope of the nation.

If Brian Turner reminds us that Iraq has a past, the presence of Dunya

Mikhail insists upon its future. *The War Works Hard* binds selections from two earlier books to previously unpublished and newer poems. It is a showcase for an original voice and unmistakable talent.

Saadi Simawe claims in her introduction that there is a touch of Emily Dickinson in the lines of Dunya Mikhail. I'm wont to agree, given the chopped metres and curt expressiveness of these opening lines to 'I Was In a Hurry': 'Yesterday I lost a country./I was in a hurry,/and didn't notice when it fell from me/like a broken branch from a forgetful tree.' It's rare to find a poet treat such material – war, exile, broken relationships – with a tone that approaches whimsical, even childlike. But, like Dickinson before her, Mikhail is notable for her departures from established trends. In 'Between Two Wars' she observes, 'We read so absent-mindedly,/eventually we forget/ how', and this poet appears to have taken it upon herself to wake others up. Thus she couches her conflicts in fable-like terms, shrugs off the easy, available clichés, and resists speaking directly, didactically, to current events.

In her most recent poems, Mikhail's metaphorising becomes even more expansive and yet self-contained, each poem upholding its gambit fully and precisely. 'Silent Movie', for example, manipulates the titular conceit in a way that must recall, for us, the black and white images of missiles reaching their targets. Also, in these later poems, Mikhail's subjects grow fraught with greater complexities. Often these arise out of the poet's own sense of exile, as in 'The Foreigner' which sees its speaker adapting to her new environment. More so, 'Buzz' gives form to its speaker's desire to explain (in 'pretty words which bubble' and 'images of smoke'), but ends on a note of self-repression: 'I don't remember what I wanted to say./I don't want to say/what I remember/ as the plane lands.'

These most recent poems encompass Mikhail's years living in the US, and the attendant internal conflict which must result. One has to wonder how this poet's imagination will manifest as the situation in her homeland progresses. In whatever terms it finds, the poetry of Dunya Mikhail is sure to continue exciting with its invention, scrutinising with a unique eye.

Stephen Lackaye

All the Colours of the Town
Liam McIlvanney. Faber. ISBN 9780571239832. £12.99

Regular readers of *Edinburgh Review* will know Liam McIlvanney as a literary critic, eighteenth-century scholar and author of such important books as *Burns the Radical*, which won the Saltire Book of the Year in 2002. *All the Colours of the Town* is McIlvanney's first foray into the world of fiction and, as is often the case with the critic turned novelist, there is a certain degree of heightened expectation. After years of dissecting texts, explaining how novels work, can the critic deliver in their own act of literary creation? Moreover, Liam is the son of well-known Scottish novelist William McIlvanney, and there will doubtless be comparisons drawn when the novel is reviewed elsewhere. Such temptations should be resisted at all turns, reeking, as they do, of intellectual laziness, preferring the clever sound-bite to a more meaningful and considered critical response.

Set in contemporary Glasgow, *All the Colours of the Town* is a thriller centred on the journalistic exploits of Gerry Conway, a hard-drinking political reporter for the west of Scotland broadsheet the *Tribune on Sunday*. The plot is briskly paced, beginning when Conway is sent a photograph of Peter Lyons, Minister for Justice at Holyrood and favourite to succeed as Scotland's First Minister. The photograph shows a young Lyons posing with Loyalist paramilitaries beneath UVF flags, flanked by men carrying pistols and wearing balaclavas. Conway attempts to uncover the truth behind the photograph, a process which takes him undercover at an Orange march in Lanarkshire, and later sees him travel to Belfast where he mixes with ex-paramilitaries, relatives of Troubles' victims, and local journalists. As a thriller, *All the Colours of the Town* has the requisite amount of cat and mouse, with Conway never more than a few pages from danger; in a scene reminiscent of the off-duty soldiers caught up in an IRA funeral in the late eighties, he is almost lynched by an angry mob at an Orange march. And in Northern Ireland he is assaulted by a UVF ex-prisoner and later dragged down an alley and set upon by a gang of men. The novel takes us within a number of private worlds, not least that of journalism and the increasing sensationalism and corporatism of the modern print media. It is also interested in a part of the Glasgow psyche where the exploits of organised crime provide the city with a unique sense of identity: 'We take solace in their formalised acts of violence, these murders in which everything – location, timing, the disposition of the corpse – has an emblematic aptness, a rhetorical neatness. Bodies dumped in

cars, the bullet up the anus, the tout clutching a bag of dogshit...'

All the Colours of the Town succeeds in alluding to the kind of deep-reaching social conspiracy upon which the thriller thrives. How involved are Conway's colleagues at the *Tribune*? The right-wing editor Rix, recently arrived from the *Daily Mail*? And fellow reporter John Moir, who himself occasionally slips back into his Northern Irish accent? And does Conway's own Catholic background put him in more imminent danger throughout his investigation? We wonder, to what degree does sectarianism still inhabit the corridors of power in modern Scottish society. And how involved was Scotland in supporting Loyalist violence during the Northern Irish Troubles? Such questions are all the more fascinating in a post-devolutionary context, with large parts of Scotland slowly distancing themselves from historical notions of Britishness.

Where McIlvanney's novel succeeds most strongly is in lifting the lid on one of the most unspoken aspects of working-class culture in the west of Scotland: sectarianism. It is notable that religious bigotry has received relatively little treatment in the work of acclaimed Glasgow writers like Alasdair Gray and James Kelman. Acting as a barometer of working-class attitudes, *All the Colours of the Town* reminds us that for the newspapers in this part of Scotland: 'sectarianism sold. It was better than sex.' It is Celtic and Rangers that make headlines, not the 'diddy teams' that no-one cares about. McIlvanney's interest in this subject is perhaps born out of his time teaching at the University of Aberdeen, which houses a centre for the comparative study of Scottish and Irish culture. McIlvanney's novel can also be read as a creative response to many of the issues raised in the recent collection *Ireland and Scotland 1700–2000*, which he co-edited with Ray Ryan. Far from the image of cosy Celtic neighbourliness, *All the Colours of the Town* reminds us that the historical crosscurrents of Irish and Scottish culture have often been unpleasant and highly unpalatable; nonetheless, such truths remain important and deserving of both our creative and critical energies.

Matt McGuire

Kolkata, Book City: Readings, Fragments, Images
Eds. Sria Chatterjee and Jennie Renton. Textualities. ISBN 9780955289644.
£8.99

For several centuries Kolkata has prided itself on being the cultural capital of India, a city of reading and a centre for literature. From Kolkata has sprung luminaries such as the nineteenth-century religious reformer and prose-master Rammohan Roy and the Nobel prize-winning poet Rabindranath Tagore. On its shores was printed the first newspaper in South Asia in 1780. In its centre lies the major repository of South Asian book culture, the Indian National Library, officially so named in 1948, but created from library collections dating back to 1835. Equally powerful evocations of Kolkata's entwinement with books can be found both in the book-lined pavements radiating from College Street near its key universities, and in the Kolkata Book Festival, an annual, riotous celebration of print that draws over a million visitors to browse, read, purchase or inhale the perfume of new and old paper and print.

This volume of fifteen essays, photographs and a short story sets out to capture in very personalised fashion the vibrancy and relevance of book culture in this Indian setting. It is a curious collection, a curate's egg of an anthology resembling the literary journal *Granta*, with its mix of reportage, first person memoir, fiction and photographic essays. The pieces collected here are from eminent Indian (and some Scottish) artists, critics, academics and literary scholars, and range from paeans on life-changing experiences in well-known Kolkata bookshops, fragmentary notes and ruminations on reading experiences and Scots-Indian cemeteries, through to excoriating criticisms of government indifference to India's book and print culture heritage, and concluding with an interview on the place of Kolkata in the literary imagination of writer Amit Chaudhuri.

The collection proves both fascinating and frustrating. There are moments of great beauty in this volume, where the clarity of expression stops and entrances, such as Margaret Burnett's evocation of the visceral immediacy of Kolkata pavement bookstalls, where 'books connected you to the vitality of streets', or Bashabi Fraser's poignant sense of personal loss on hearing in 1994 of the destruction by fire of a Kolkata institution, the Dasgupta and Co. bookshop.

Equally, one learns a great deal about books and popular culture, as in the case of Sukanta Chaudhuri's short survey of the provision and circulation

of chapbooks, or cheap pamphlet-sized books, in Kolkata and its outlying district markets. The subject-matter of such chapbooks, though crude and cheaply done, ranges far afield, from popular religious devotionals and poems to astrology, self-improvement, song books, short fiction and instructional texts, providing invaluable aid in sustaining reading amongst the growing literate class of West Bengal. As if to keep the reader off-balance, this learned disquisition on popular reading is immediately followed by a disruptively carnivalesque short story by Rimi Chatterjee, focused on a day in the life of a pornographer versed in the classical Indian mythological traditions. Popular culture meets classical practice in every piece in this collection, as Aditi Das Gupta proves with her short note on the British romances and crime fiction to be uncovered in the Loreto Library, part of the college founded in Kolkata by Irish nuns in 1912 for the education and moral improvement of young girls.

At other times one longs for contributors to expand their short essays on the workings of the Kolkata book scene into more substantial contributions. Santanu Sanyal's short profile of an itinerant book pedlar, for example, omits as much as it reveals – so missing an opportunity to offer some historical perspective to contextualise this individual's experiences of book-selling on the hoof. Scotland has had some fascinating studies in recent years delving into the cultural significance of the wandering book pedlar; Indian examples deserve equally full inquiry, which this piece tantalisingly leaves only half-completed. Equally, Jennie Renton's brief note on links between the Scottish publisher Collins and an Indian bookseller, nurtured by Collins's Indian-based representative pre-Indian partition of 1947, offers tantalising historical information on the business circles linking Scottish and Indian book producers and sellers, but seemingly runs out of time to hunt further on the matter. Less satisfying are some short studies of bookshops and publishers that seem more akin to promotional bulletins than to sturdy histories. These, luckily are few in number, their effect outweighed by the general, positive passion for books that buoys the general contents of this informative and eclectic celebration of Kolkatan print and the literary imagination.

David Finkelstein

Absent: a novel
Betool Khedairi. Random House (USA). Translated by Muhayman Jamil.
ISBN 978081297424. $13.95

Betool Khedairi, daughter of an Iraqi father and a Scottish mother, was born
in Baghdad in 1965 and lived there till the age of 24. *Absent* is the story of the
ordinary people of Baghdad under bombardment and sanctions and as such
is an unique contribution to contemporary world literature. Khedairi is now
in exile in Amman, Jordan.

 In a 2003 interview with Brigitte Voykowitsch, in *Die Gazette*, Khedairi
said: 'I left Baghdad, but it never left me. I carry it in me like a compass.
It is my place of birth, my childhood, my education. Every time I sit down
to write, I have an enchanting dialogue with my ancient civilization. It is
around six thousand or more years old, and still inspires me. I am so sad to
see it go through three wars in the past twenty-five years. My best memories
of it are memories of the city in times of peace. Baghdad for me is the focal
point. I concentrate on this wonderful feeling of going back there one day,
and that helps me through the days I spend away from it.'

 Absent is an important novel since it converts a political abstraction into
a world of flesh and blood, devastated by an alien, imperial power. Khedairi's
characters live under conditions of extreme stress, experiencing daily arrests,
betrayals and deprivation. Damaged by war, they struggle to survive.

 Khedairi's own life has been distorted by three crises: eight years of war
between Iraq and Iran, the invasion of Kuwait in 1990–91 and the US-led
occupation of 2003. Her wry comment on this in a 2007 article in the *San
Francisco Chronicle* is: 'Between the exported nightmare fantasy of weapons
of mass destruction and the imported dream of democracy, I concluded that
black comedy was the best style for my new novel.'

 Comedy is provided by the exploits of the inhabitants of an apartment
block in Baghdad in the 1990s, each floor representing a different social class
and all trying to survive after the Gulf War. The narrator is Dalal, a young
girl in her twenties with a facial deformity – the effect of a stroke. The reader's
attention is focused on her dysfunctional family. A landmine from the 1967
conflict killed Dalal's parents and she now lives with her warring aunt and
uncle. Throughout, Dalal is the passive recipient of intense experiences
which she tries to understand. Khedairi also attempts to find meaning in
the confusion and destruction caused by world politics, as well as in her
own divided inheritance, being both Iraqi and Scottish. Writing in *Guardian*

Unlimited, in 2006, Khedairi said: 'As a teenager in Baghdad I witnessed the Iraq-Iran war. In England as an adult, it was devastating to see my western half attack my eastern half during the first Gulf war through the lens of the western media.'

Both Khedairi and her narrator suffer from a sense of total helplessness in the face of confusing events: 'the wheel of fire just rolled on.' In effect, Khedairi explains that her motivation for writing is to 'find meaning'. In *Absent* she presents an abnormal situation in which there are few male characters since so many men have died in the fighting; the 'story' is shown through the dialogue and inventiveness of several forceful women.

Khedairi claims in the 'Afterword' that she named the novel *Absent* 'to symbolize the dilemma of the Iraqi people [who] had been excluded, and were "absent" from the international scene for decades. The civilization that had invented writing was now slipping into darkness as a result of wars, sanctions, and dictatorship. For thirty-five years Saddam remained the father of the absent Iraqi people. I needed to give birth to their story.'

Absent ends optimistically with Dalal teaching the newspaper boy to read and write. She tells him, 'If you can't read, how will you know what the world wants from us?' Khedairi's achieved intention is to tell the world about Iraqis as human beings, in the process, deconstructing the distorted stereotypes of the media. As in her earlier novel, *A Sky So Close* (1999), Khedairi's concern is with the human, not the political, dimension. In her own words in the *Die Gazette*, interview in 2003: 'If we could only build bridges between East and West instead of fighting the differences, then maybe we would come one step closer to a peaceful planet.'

Faith Pullin

I'jaam: An Iraqi Rhapsody
Sinan Antoon. Translated by Rebecca C. Johnson and Sinan Antoon. City
Lights. ISBN 9780872864573. $11.95

Born in Baghdad, the son of an Iraqi father and American mother, Sinan
Antoon studied English Literature at Baghdad University, moving to
America after the First Gulf War. He has had direct experience therefore of
life in Saddam Hussein's Iraq, the setting for this short novel, subtitled 'an
Iraqi rhapsody'.

'Rhapsody' seems at first sight a strange word to use of a narrative which
alternates poignant memory with present horror against the background of
the Iran-Iraq war. Moments of rapture are brief. The most everyday experience
is charged with fear, and the central experience of the protagonist, Furat,
is brutal imprisonment; but in its musical sense, 'composition of irregular
form, suggesting improvisation', 'rhapsody' is in fact an apt definition of this
series of disjointed episodes, half real, half imagined, linked by the painfully
clear vision of its narrator.

The sub-title reflects the ambiguity which is at the heart of the novel's
structure, a reflection of the ambiguity of a society in which the 'great Father-
Leader' can exhort writers to '[W]rite without any concern or hesitation
that the government may or may not be satisfied with what you write' while
imprisoning a man apparently for his subversive poetry. The narrative purports
to be a transcription, on the orders of an official from the Ministry of the
Interior, of a manuscript found in a filing cabinet, a manuscript without any
of the dots which indicate the meaning of words in Arabic script, hence the
novel's title: 'I'jaam' originally meant 'dotting' and through that has come to
mean both 'making something clear' and 'making something ambiguous'.

At some points the transcriber seems to copy a word as it appears on
the page and offers a conjecture as to the word intended: the 'simulation of
Democracy' is conjectured to be 'celebration', 'The National Regress' to be
'National Congress', and so on. There is more to this than the obvious satire.
The reader is deliberately left in the dark as to whether the transcriber allows
this 'frequent profanity' into the transcription because, as he says, it 'could
help to identify the writer', or because he is himself a sympathiser with the
narrator's views. No attempt is made, other than in the ambiguous, repeated
sentence 'I awoke to find myself (t)here', and the occasional insertion of a
date, to differentiate actual experience (such as the narrator's rape by one of
the prison officials) from hallucination (a television programme in which the

government is urging people to 'donate their eyes' for the war effort). In this world, reality is nightmare and nightmare reality.

The novel begins with the tender image of two clouds kissing, emblematic of the natural attraction which draws together the narrator and Areej, a wealthy fellow student. We are allowed glimpses of normal human concern, still existing in dehumanizing circumstances. Furat's Christian grandmother, forever lighting candles for his safety, is observed with humour and sympathy. Yet even the seemingly unforced attraction of the lovers to each other has its taint of suspicion – 'How do I know you aren't one of them?' is an uneasy joke; a student's warning to Furat to take care, is greeted with the wary 'why should you care?' Behind the fragmented, horribly vivid pictures of his past and present experience which Furat creates as a way of affirming his own reality lies the history of Iraq itself, sketched in, with the lightest of touches, in the episode in which Furat and Areej come upon a cemetery full of the graves of British soldiers killed during the 1917 invasion: 'the time of the British has passed. It's the age of America, and it's not like they'll occupy us'. At the time in which the novel is set, America was backing Saddam Hussein. The seemingly casual remark resonates.

Despite the deftly slipped-in historical references, and Antoon's stated intention to give voice to the sufferings of Iraqis when they were being largely ignored by the West, the action could be set in any brutal dictatorship. It is not accidental that the narrator, before his imprisonment, wishes to make Orwell's *Nineteen Eighty-Four* the subject of his thesis – only to discover that it has been banned. The parallel between 'Big Brother' and the ubiquitous pictures of the (unnamed) Leader is underscored without ever being overtly stated. This is an imagining not only of one writer's imprisonment in a specific country, but of the ways in which governments try to imprison thought itself.

In an acknowledgement, Antoon thanks Rebecca C. Johnson, who collaborated with him on the translation, for allowing *I'jaam* 'to speak in another language'. The excellent translation, which copes even with the puns, can itself be understood as a work of setting free a distinctive voice: sharp, grimly humorous, humane, a compelling spokesman for the silenced.

A.C. Clarke

Marie B.
Tom Hubbard. The Ravenscraig Press. ISBN 9780955655913. £12.95

I began by stumbling slightly over the form of this book, which seems like a series of experimental texts rather than a conventional biographical novel, but by the end, had to confess myself enchanted by it, and by Marie. As, no doubt, Tom Hubbard himself has been for a number of years.

Marie Bashkirtseff was a young Ukrainian aristocrat, who spent most of her life in France. Her self-portrait stares out from the cover of the book: defiant, attractive and remarkably candid: an astonishing piece of work for any artist, never mind a young woman of her background, working at a time when the lives of women were so heavily circumscribed. When she died of tuberculosis in 1884, at the age of 25, she left behind a collection of accomplished paintings, including the extraordinary 'Un Meeting', as well as many volumes of equally candid personal diaries, which have rather superseded the paintings in terms of comment. There is a good deal of opinion about Marie and her diaries out there. She was young and self obsessed, as which of us is not, at that age? Her creative ambitions set her apart from other young women. But the struggle to make a name for herself was monumental and that she had the courage to undertake it at all is worthy of praise. That she undertook it with such magnificent results is astounding. 'I am the most interesting book of all', says Marie. She's right, and Tom Hubbard is right too to recognise the fact.

Hubbard has taken extracts from the diaries and interwoven them with key scenes from Marie's life and work, as the blurb has it, 'with an occasionally Scottish accent'. That the whole is so magical has a great deal to do with Marie herself, or at least the writer's fascination with her, but also with his ability as a poet to encapsulate complex ideas within deceptively simple prose forms. Having read the book, the first thing I did – of course – was to type Marie's name into Google, and look at the surviving pictures. Which is just what Hubbard might have intended. I loved this book, not least because of all that it did not say. The spaces and silences are as eloquent as the writing. But of course that is exactly as it should be, given that this is a book by a poet about what it means to be an artist.

Catherine Czerkawska

Notes on Contributors

Hassan Abdulrazzak is of Iraqi origin, born in Prague and living in London. His first play, *Baghdad Wedding*, premiered at Soho Theatre in 2007. Hassan was awarded the 2008 George Devine and Meyer-Whitworth awards. He works full time as a cell and molecular biologist at the Royal Veterinary College.

Hannah Adcock is a graduate of Cambridge University and freelance writer who has been commissioned to write articles for both the national and regional press. Her first book, *Twentysomething: The Ultimate Survival Guide* (Discover Press, 2004) was published when she was twenty-three. She is Director of the West Port Book Festival in Edinburgh.

Keith Aitchison lives and works in Inverness. His stories come mainly from events, places and people encountered, then sitting in memory, often for years before emerging onto the page, usually as something very different.

Anmar Al-Gaboury was born in 1990 in Baghdad, Iraq. He started drawing at the age of six. In 1999 Anmar got interested in Graphic Design, influenced by his three uncles in Amman, Jordan. He now works as a graphic designer and photographer in London.

Salam Al-Asadi (1963–1994) was an eyewitness to the bombing of his home city, Nasiriyya, in southern Iraq. He took part in the uprising following the end of the Gulf War and became a refugee, first in Saudi Arabia and later in the US where he died in a traffic accident in 1994.

Zuhair Al-Jezairy is currently editor in chief of Aswat al-Iraq news agency and part of the Iraqi Journalist Union. He was the previous editor in chief of the daily Arabic newspaper *Al Mahda*. He studied German literature in Baghdad and since 1968 has worked as a journalist in Baghdad, Beirut and London.

Gary Allen has published five collections of poetry, including *Iscariot's Dream* (Agenda Editions, 2008), and *The Bone House* (Lagan Press, 2008). He Lives in County Antrim, Northern Ireland.

Hussain Al-Mozany works as an author, translator and journalist. Born in 1954 in Maimuna, near Amarah in southern Iraq, he grew up in Baghdad and moved to Lebanon in 1978. Since 1980 he has been based in Germany. His more recent work, in the German language, includes several short stories; a play, *Klara und Abbas*; and the novels *Das Geständnis des Fleischhauers* (Schiler, 2007), *Mansur oder der Duft des Abendlandes* (Reclam, 2002) and *Der Marschländer* (Glare Verlag, 1999).

Salih J. Altoma, Professor Emeritus of Arabic and Comparative Literature, has been affiliated with Indiana University since 1964. His publications include several books, bibliographical surveys and numerous articles in Arabic and English which cover modern Arabic literature, Arabic–Western literary relations and English translations from Arabic. Among his most recent books are: *Fi al- 'alaqat al-adabiyyah bayn al-'arab wa al-gharb* (On Arabic-Western Literary Relations) Jeddah's Literary Club, 2003, and *Modern Arabic Literature in Translation: A Companion* London: al-Saqi, 2005.

Sinan Antoon's poems and essays have appeared in *Ploughshares, World Literature Today, Bomb* and *The Nation*. He is the author of *The Baghdad Blues* (Harbor Mountain Press, 2007) and *I'jaam: An Iraqi Rhapsody (City Lights)*. His translation of Mahmoud Darwish's *The Presence of Absence* is forthcoming from Archipelago Books.

Charles Bennett's latest collection, *How to Make a Woman Out of Water*, was published by Enitharmon in 2007. After six years as Director of Ledbury Poetry Festival, he is now Field Chair in English and Leader of the BA in Creative Writing at the University of Northampton.

Lynsey Calderwood lives in Renfrew. She speaks a bit of Gaelic, and plays a bit of saxophone; and last year she received an SAC bursary to help fund research costs for her novel-in-progress, *The Piper's Son*.

Steve McGregor is a former Captain in the US Army Infantry who served in the 3rd Brigade of the 101st Airborne Division in Iraq. This autumn he begins postgraduate studies in Social Anthropology at University College London. He currently attends a writers' group at Eastside Bookshop on Brick Lane and is writing a novel about the Iraq war.

Andrew Philip lives in Linlithgow and works part time for the Scottish Parliament. His first full collection of poetry, *The Ambulance Box*, was published by Salt in March this year. He has also published two successful pamphlets with HappenStance Press: *Tonguefire* (2005) and *Andrew Philip: A Sampler* (2008).

...**Shampa Ray** was born in New Dehli. Her poetry has been published widely in anthologies – *Wish I Was Here* (Pocketbooks); *Rising Fire* (FWBO), and magazines – *Fox, Textualities, Edinburgh Review*. Her work was exhibited in *Mists and Monsoons* in the Writers Museum, Scotland in 2007. She is an artist and nature conservationist

Gerda Stevenson, actor/writer/director, has had poetry published in *The Scotsman, Cencrastus, The Eildon Tree, Parnassus: Poetry in Review, Cleave* (Two Ravens Press), *New Writing Scotland,* and *Aesthetica Magazine*, and was awarded an SAC Writer's

Bursary (2008). Her many BBC Radio 4 dramatisations include *The Heart of Midlothian* and *Sunset Song*.www.gerdastevenson.co.uk

Radhika Dogra Swarup spent a nomadic childhood in India, Italy, Qatar, Pakistan, Romania and England. She studied at Cambridge and worked in finance before turning to writing. Her work has been published in India and the UK. She is currently working on a collection of short stories and lives in London.

Saadi Youssef was born near Basra in 1934. He has published over thirty volumes of poetry. *Without an Alphabet, Without a Face*, his selected poems translated by Khaled Mattawa, were published by Greywolf in 2002: He has also published seven books of prose. Currently he lives in London.

Haifa Zangana is a novelist, artist, and activist. She is the author of *City of Widows: An Iraqi woman's Account of War and Resistance* and co-founder of Women's Solidarity for an Independent and Unified Iraq. She writes a weekly column for Al Quds and lectures regularly on Iraqi literature and women's issues.

Acknowlegements

'The Clay's Memory' and 'Gunpowder' by Salam al-Asadi, translated by Salih J. Altoma, first appeared in the online literary journal *Free Verse: A Journal of Contemporary Poetry & Poetics* http://english.chass.ncsu.edu/freeverse/ published by the Department of English, North Carolina State University. 'Baghdad' by Haifa Zangana, is from her novel *Dreaming of Baghdad* (the Feminist Press, 2009). This extract is published here by kind permission of the publisher. 'You Will Be Next' by Zuhair al-Jezairy is from *The Devil You Don't Know*, (Saqi Books, 2009) and is reprinted by kind permission of the publisher. The editors gratefully acknowledge the invaluable assistance of Ryan Van Winkle, Julia Boll, and Iraqi artist and activitist Rashad Salim, in compiling this issue of *Edinburgh Review*.